ERNEST GRISET

Fantasies of a Victorian Illustrator

Lionel Lambourne

with 130 illustrations
8 in color

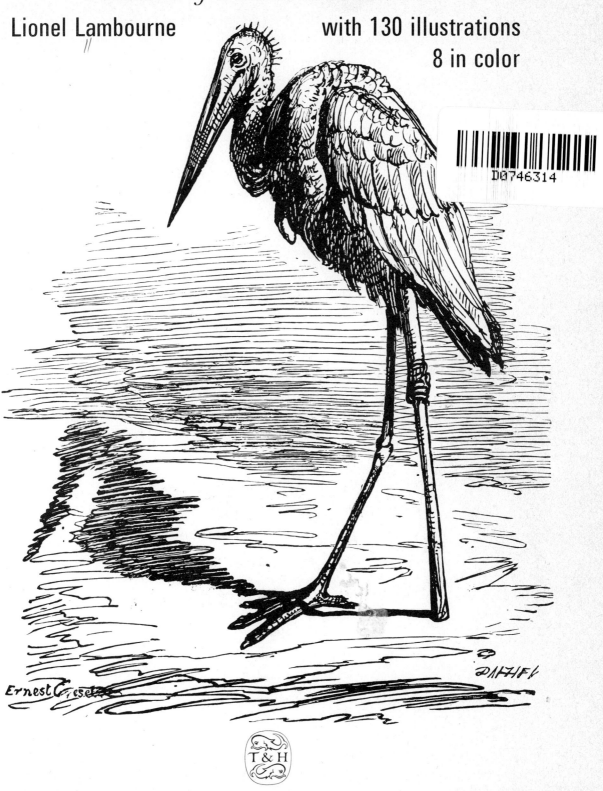

Ernest Griset

Thames and Hudson

To Ernest Knight, Griset's grandson, without whom

The only known photograph of Griset,
reproduced from M. H. Spielman's
The History of Punch, London 1895.

Dimensions are given in centimetres
and inches, height before width.

Library of Congress Catalog Card Number: 79-4940

Text and monochrome illustrations printed in Great Britain
by BAS Printers Limited, Over Wallop, Hampshire
Colour illustrations printed in Great Britain by
Balding & Mansell Limited, Wisbech, Cambs.
Bound in Great Britain

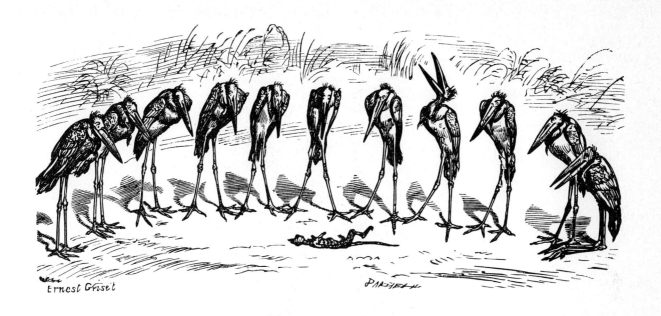

Ernest Griset

Contents

Introduction

'Can anyone fancy what this world would be like if inhabited by no other animal than man?' These words begin a long-forgotten little book, *Our Poor Relations* by E. B. Hamley, published in 1872 and illustrated by Ernest Griset. The book attempts to answer this rhetorical, but for twentieth-century readers, all too pertinent question, and concludes that without animals the world would be a sad and boring place. 'There are other proper studies of mankind besides man.'

There could have been no more appropriate illustrator to such a book than Ernest Griset. Indeed, the book's message might almost serve as a summary of his life's achievement. He was a man who loved animals, and spent a long career producing two very different types of work celebrating that love.

The first type consists of straightforward naturalistic studies of individual species. They are both brilliantly observant and full of life.

The pictures of the second type, grotesque fantasies of animals either in human guise or behaving in a human manner, are both amusing and memorable, like *The Dream of the Fisherman*, which combines an ironic comment on the piscatorial pleasures of Izaak Walton's human *Compleat Angler*, with an evocation of what might be described as the wish-fulfilment of a pelican's dream.

What sort of personality produced these very different works? Griset's quiet, hard-working but ill-rewarded life can be briefly described. But before doing so it is necessary to place his life in context. His unfamiliar work, just because it is so little known, throws into relief the Victorian preoccupation with the interrelationship of man and animals. It takes its place with that of Landseer, Tenniel (whose illustrations to *Alice's Adventures in Wonderland* may owe something to Griset), Edward Lear, Beatrix Potter and the Martin Brothers, as part of the recurrent mystery of the anthropomorphic impulse, by which man, by his artistry, achieves the status of God, and remakes creation to his own fancy.

Let us begin then with a consideration of some earlier examples of man's strange delight in seeing in animal creation a distorting mirror of his own image. This often takes the form of giving animals human attributes, and human beings animal attributes, and is the sense in which the word 'anthropomorphic', so various in its definitions, is used in these pages.

The Anthropomorphic Impulse

Animals have always, from prehistoric times until the end of the nineteenth century, provided man, the artist, with one of his most eternal themes: the realistic depiction of animal creation. It would be strange if this were not so, due to the close proximity of man to his animal neighbours, who are his enemies and slaves. Parallel to this theme, another more complex one has developed: the use of man/animal, animal/man imagery to hold up a distorting mirror to the morals, behaviour and character of man. This theme can be described as the 'anthropomorphic impulse'.

In our century the use of the animal as a straightforward theme in art has greatly diminished. Certainly, some great modern artists like Picasso with his superb aquatint illustrations to Buffon, and Henry Moore with his lithographs of elephant skulls, have occasionally used animal themes. But such examples do not form the central body of their work. Specialist ornithological artists, it is true, cater for the inexhaustible demand for pocket books identifying wild birds, but on the whole the artist no longer finds inspiration in the animal kingdom. This is to a large extent due to the supremacy of the camera as a recorder of wild life. Television can today bring the most intimate details of the daily life of the rarest species into our homes at the touch of a button. Zoos, wildlife parks, natural-history museums abound. Yet, paradoxically, while modern urbanized man has at his command extensive academic knowledge about animals, it is perfectly possible for him to go through life without coming into any direct contact with another species, except with a knife, fork or spoon. The animal now comes 'gift-wrapped', whether dead from the factory farm, or alive from the television screen. Day to day contact with animals, except with the domestic dog or cat, or, more rarely, the horse, is now the exception, whereas in previous centuries it was the norm.

But this remarkable change has not yet been reflected in our use of language. Animal metaphors of amazing complexity still abound in our daily speech. The lion still symbolizes royalty, bravery and hunger; the bull, virility; the dog, fidelity; the bitch, sexual promiscuity; the hawk, sharp sight; the gannet, the ability to swallow large quantities of food. The association of human characteristics with animals still remains, despite our detachment from the realities of the lives of other species. Indeed, surprisingly, the

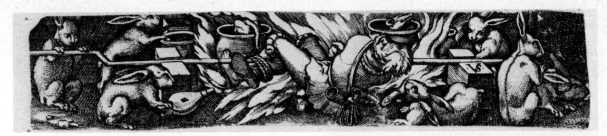

anthropomorphic impulse has developed, rather than diminished, in the present century. While literature, with Kafka, Čapek and Orwell, and the Surrealist movement, with Ernst, Dali and Chirico, can supply significant examples of the process in action, some of the most striking developments have taken place in the work of the Walt Disney studios. In *Snow White, Bambi, Fantasia, Pinocchio, Dumbo* and *The Lady and the Tramp*, birds, deer, skunks, crickets, dogs and cats strike moral attitudes and adopt human behaviour, while elephants fly and hippopotami dance.

The work of Ernest Griset forms a fascinating nineteenth-century anticipation of such contemporary work. For him, too, in imagination, hippopotami danced. His work forms a significant link in the chain of animal fantasy which connects Kermit, the frog in *The Muppet Show*, with Aesop's Frog King.

While the use of animal imagery in the world's major religions is a rewarding and complex theme, it is more convenient in this study to use Aesop as a point of departure. He is said to have been a slave in Samos in the fifth century BC, but his fables were collected together as a group in about 300 BC by Demetrius of Phaleron. These short stories are used with the aphoristic force of parables to mirror satirically foibles of human behaviour, as in such famous tales as 'The Fox and the Grapes', 'The Lion and the Mouse', and 'The Ant and the Grasshopper'. Ever since their creation they have served as classic texts for innumerable adaptations, from La Fontaine and Sir Roger L'Estrange to Sir Edward Marsh. Variations on similar themes range from Chaucer and the satire of *Reynard the Fox*, to the humble, homely humour of Joel Chandler Harris's tales of Uncle Remus. They have also provided a superb theme for illustration, from the first appearance of the printed book. Indeed, in the thirty years before 1500, more editions of *Aesop's Fables* were printed than of the Bible, many of them illustrated. During the Renaissance, its appeal diminished, but Oudry's illustrations of 1755–9 were copied on countless French paintings, tapestries, carvings and ceramics. In our own day, Alexander Calder's wiry, witty illustrations to Sir Roger L'Estrange's translations are testimony to the classic's continuing appeal. Ernest Griset was himself to produce an illustrated Aesop in 1869.

The Gothic period produced many masterpieces of animal fantasy, from the Unicorn tapestries at the Cluny Museum to the gaiety of a misericord at

Above, a sow-piper and her dancing piglet. From a fifteenth-century misericord in Ripon Cathedral.

Top, hares roasting a hunter and his dog. Engraving by Virgil Solis (1514–62). 2.2 × 10.9 ($\frac{15}{16} \times 4\frac{11}{16}$). By courtesy of the Victoria and Albert Museum, London.

Ripon Cathedral on which a pig plays the bagpipes. Virgil Solis's engraving of hares roasting a hunter, probably derived from a decorative border in an illuminated manuscript, is expressive of the egalitarian mockery that typifies Gothic attitudes to the depiction of the animal. It was not until the Renaissance that a new objective spirit of scientific investigation begins to appear. But the allegorical and metaphorical value of animal comparison was too powerful and useful a narrative aid ever to disappear completely.

Two eighteenth-century works perfectly represent this dichotomy of approach to animal themes: George Stubbs's *Anatomy of the Horse* and Jonathan Swift's *Gulliver's Travels*, Book IV. Both works take as their theme the horse, the animal which then represented the principal means of transportation and recreation. The anatomy of the horse has always provided the artist with the greatest aesthetic discipline after the study of man himself. Stubbs was to take this discipline to its furthest extent in a series of

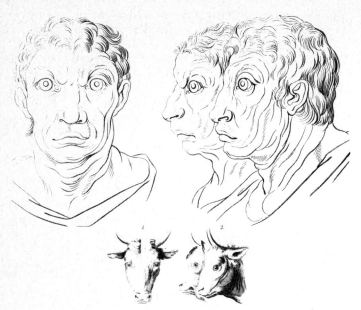

A page from Lavater's *Physiognomische Fragmente*, Leipzig and Winterthur 1775–8.

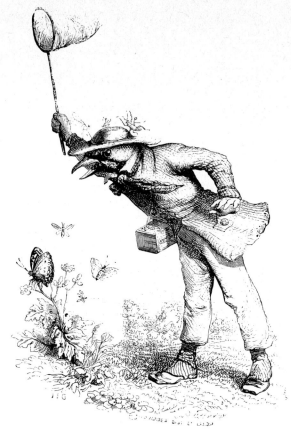

The shrike as butterfly collector. An illustration by Grandville from *La Vie Privée et Publique des Animaux*, Paris 1842.

drawings which remain unsurpassed for their scientific observation and aesthetic quality.

Swift uses the horse satirically as a noble contrast in behaviour to the rapacity, greed and bestiality of man, the Yahoo. Such a process found a visual equivalent in the 'Singeries' of Boucher, Chardin and other members of the French eighteenth-century school, in which monkeys were used as a sardonic parallel to such human activities as voyeurism, hypochondria and antiquarianism.

These comparisons of human and animal physiognomies were derived from a widespread physiognomical doctrine ascribed to the authority of Aristotle. In a book, *De Humana Physiognomia*, published in 1586, G. R. Della Porta first provided an extensive illustrative analysis of such comparisons, and provided a source which was frequently exploited by later caricaturists. These theories were further developed by Johann Caspar Lavater whose *Physiognomische Fragmente*, published at Leipzig and Winterthur between 1775 and 1778, elaborated the doctrine into what he described as an exact science. With its aid, he claimed, one could 'know the inner man by the outer ... apprehend the invisible by the visible surface'. Although Lavater was himself an accomplished draughtsman, he commissioned the illustrations for his work from the caricaturist Chodowiecki. The technique of successive transitions, a weird anticipation of Darwin's law of evolution, developed Della Porta's imagery still further, to the advantage of caricaturists.

Lavater's researches present with Teutonic thoroughness and genius for categorization half of the great fundamental rule of the anthropomorphizing process: i.e., when man is depicted as an animal the result is satirical and bestial. He omitted the other half of the rule – that when an animal is depicted as a man the result is whimsical and sentimental – but this

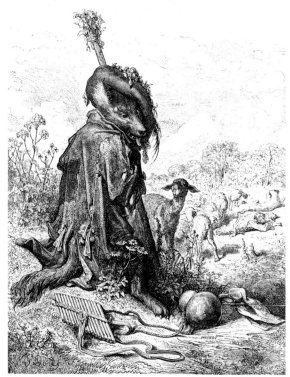

The Wolf Turned Shepherd. An illustration by Gustave Doré from *Fables de La Fontaine*, Paris 1867.

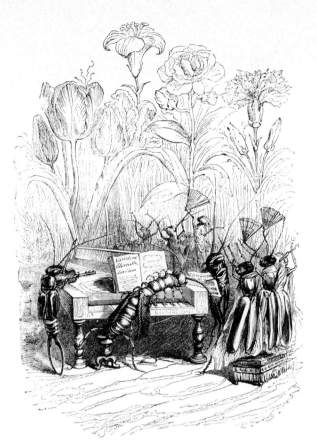

A characteristic insect fantasy by Grandville from his *La Vie Privée et Publique des Animaux*, Paris 1842.

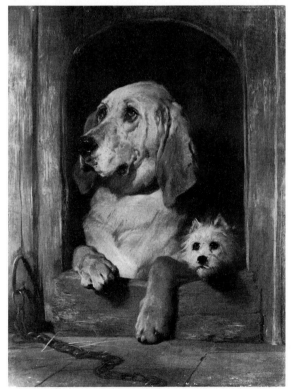

Dignity and Impudence by Landseer. Oil painting. 1839. 92.5 × 68.1 (37 × 27¼). By courtesy of the Tate Gallery, London.

converse process can be easily visualized by recalling the work of Beatrix Potter, or Arthur Rackham and E. H. Shepherd's illustrations to *The Wind in the Willows*. (It is interesting to note that Graham may have based the character of Toad partly on Oscar Wilde.)

In the early nineteenth century Lavater's theories were most strikingly demonstrated by the work of Grandville (1802–42), whose strange fantasies so alarmed Baudelaire. Grandville took anthropomorphism to the limit of artistic expression, elaborating such apposite analogies as the ant-eater, with his long snout and tongue, with the customs official, the shrike as human-butterfly hunter and the poetic image of fish fishing for men. But his greatest achievements, and those which probably most influenced Ernest Griset, were the insect fantasies like the centipede playing the piano, satirizing the virtuosity of Franz Lizst.

While Grandville's extraordinary anticipation of Surrealism's use of animal imagery diverted and alarmed France, in England, the nation of animal lovers, Sir Edwin Landseer began in the 1830s his successful career as a painter of canine genre subjects. Such works varied from the poignant sentiment of *The Old Shepherd's Chief Mourner*, praised by Ruskin 'as the most perfect poem or picture of modern times', to the pawky humour of *The Twa Dogs* (after Robert Burns' anthropomorphic canine satire) and the broad knock-about comedy of human affairs in *A Jack in Office*. In paintings such as these, and *Dignity and Impudence*, Landseer played successfully on the public's emotional response to the human qualities of dogs. His work, thanks to its widespread dissemination in the form of engravings, became immensely popular.

Ernest Griset himself was to show a knowledge of the work of both these artists, producing indeed several amusing parodies of *Dignity and Impudence*. But although it was this comic aspect of his art which was to gain him his greatest public renown, he was also to derive much of his individual ability as a draughtsman from careful hours of observation in the Zoological Gardens of London, and through contact with its often eccentric guardians.

The Struggle for Life

n the *Origin of Species by means of Natural Selection, or the Preservation of Favoured Races in the Struggle for Life*. The full title of Charles Darwin's famous book, published in 1859, provides an ironic gloss on Griset's career. He was just *not* one of those favoured in the struggle for life and fame either as a humorous draughtsman or as an artist. He first achieved recognition for his quirky animal caricatures, extremely topical during the immediate 'post-

Darwinian' decade of the 1860s, which reverberated with the controversies provoked by the publication of the great scientist's book. But once their vogue was over Griset did not, *could not*, enlarge the range of his choice of comic subject material to achieve the sustained success of a contemporary caricaturist like Sir John Tenniel. Fate decreed, with bitter irony, that being by now so well known as an animal satirist, he could not change direction, and become a successful 'straight' animal artist like Joseph Wolf. Griset's life is a classic example of the dangers of falling between two stools.

He was born in Boulogne, France, on 24 October 1843, and brought over to England while still a child. The remainder of his life was passed chiefly in areas of north London: Hampstead, Highgate and Kentish Town, conveniently adjacent to the gardens of the Zoological Society. There, in imagination, he was to make many voyages of discovery to far-off, exotic lands.

It is recorded that he studied art under Louis Gallait (1810–87), a Belgian painter of painstakingly researched history pictures in the grand *salon* manner. But it is doubtful if this experience amounted to more than a few months' attendance at the artist's studio in Brussels or Antwerp. Just as every comedian's ambition is said to be to play Hamlet so, in Victorian times, many caricaturists, like George Du Maurier and Dudley Hardy, began their careers by aspiring to become history painters, and studying under Belgian Academic artists. The professional knowledge of oil-painting technique gained by such training played little part in the development of their later work, although the academic training in drawing from the figure was of lasting value.

Far more important to Griset's development as an artist was the fact that his French parentage and stay in Belgium made him fluent in both English and French. The 1840s and 1850s, during which his formative years were passed, was a period of political turbulence, in which exceptionally brilliant satiric journals and caricaturists flourished on both sides of the Channel. Griset was, by his origins, singularly well situated to study both French and English comic draughtsmanship at a time of golden opportunity for caricature.

In England the foundation of *Punch* in 1842 provided a platform for a galaxy of illustrative artists, notably John Leech and Richard Doyle. Leech's good-humoured versatility made him admirably suited to supplying the unending demands for political and social satires. But Griset probably had greater admiration for the protean fancy of Doyle whose *Foreign Tour of Brown, Jones and Robinson* he was later to emulate. *Punch* had itself been founded in imitation of the Parisian *Le Charivari*, the controversial journal which scourged the bourgeois hypocrisy of the France of Louis-Philippe, in a series of satiric works by Grandville, Philipon, Cham and, most notably, Honoré Daumier. Both Grandville, and more surprisingly, Daumier, created a veritable political bestiary of anthropomorphic caricatures, which must have become familiar at some stage to the young Griset. With such weekly examples before him, he was now ready, like one of the insects he loved to depict, to emerge from the chrysalis, and become a fully fledged caricaturist.

Griset initially came to public notice in a way that is all too rarely available to young artists: by setting up shop and selling his wares direct to the public, charging extremely low prices. In the mid-1860s he established himself in a small bookshop near Leicester Square in Suffolk Street, and produced rapid pen-and-ink sketches and watercolours which were purchased by appreciative passers-by, who enjoyed seeing, in the words of a contemporary reviewer, the 'powerful and eccentric' works done on the spot. One of the earliest of these works to survive records a more imaginative act of vandalism than we are usually accustomed to today. On the night of 16 October 1866, an old statue of George I seated on a horse, which stood in Leicester Square, was painted over with black spots; pointed horns were fixed over the horse's ears, a large pointed cap was fixed on the King's head, and a stave topped by a birch broom was rested against the King's left side, where the lower part of his arm and leg were already missing. The initials A.D.G. on either side of the plinth were brought out in bold relief.

While the chance of recording such an odd prank was obviously too good for Griset to miss, the majority of these early productions were probably on the lines of *A Traveller confronted by Crocodiles*, the theme of artist and animal which Griset was to make so much his own, or of diverting drolleries like *The Rivals*.

Such work brought Griset to the attention of the editors of *Fun*, a humorous magazine, sold for a penny a week, which had commenced publication in the early 1860s, as a 'down-market' version of *Punch*. In the pages of this journal he began to produce a series of comic drawings of zoological and natural history subjects which exactly hit the mood of the time. Although Darwin's book had been published in 1859, it remained violently controversial for several years, for the Church and Establishment were shocked at what they considered blasphemous doctrines. In their turn, free spirits ridiculed such obscurantist views as reactionary. At such a time the arrival of a new species of animal at the Zoological Gardens could be used as fresh fuel to stoke the fires of controversy. Debates on the vexed question of the 'Descent of Man' divided society into two opposed camps – 'Darwinians' and 'Anti-Darwinians'. In 1860, Bishop Wilberforce of Oxford ('Soapy Sam') had offensively asked Thomas Huxley, who described himself as 'Darwin's Bulldog', whether he was related 'on his grandfather's or grandmother's side to an ape'? Huxley made the crushing reply that he would prefer to have a monkey for his grandfather than to be related to a man, who, like the Bishop, 'plunges into scientific questions with which he has no real acquaintance'. In a debate at the Oxford Union,

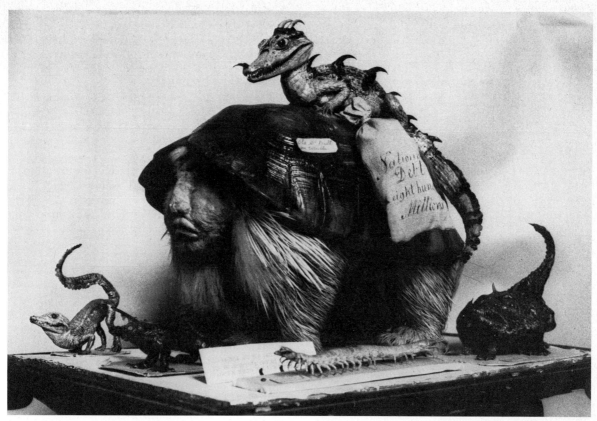

Taxidermic freak by Charles Waterton, satirizing the National Debt. By courtesy of the Wakefield Museum.

Disraeli, with his customary felicity of expression, posed the question whether he was descended from an ape or an angel, and declared himself to be on the side of the angels.

Savour was added to these arguments by the amiable eccentricity that was such a characteristic of so many Victorian natural historians. Griset was on familiar terms with several of these men, and derived inspiration from the often hilarious anecdotes that enliven their books and scientific papers.

For sheer eccentricity, pride of place must go to Charles Waterton (1782–1865). Dame Edith Sitwell, in *English Eccentrics*, has paid a moving tribute to the many wonderful exploits of this most lovable of naturalists, but a work on Ernest Griset would be incomplete without some mention of the author of *Wanderings in South America* (1825), the stories in which read like real-life descriptions of Griset drawings. Charles Waterton, sleeping with his big toe out of the mosquito-net in order to give a thirsty vampire bat a drink; riding a crocodile; holding a sprained ankle under Niagara Falls; hugging a savage orang-utan at the Zoo; and at home in Wakefield establishing the first English nature reserve – this is the stuff of legend. His taxidermic freaks, which can still be seen at Wakefield Museum, have a wild humour that makes them almost three-dimensional anticipations of Griset's grotesques.

Although Waterton died in 1865, his amiable spirit lived on in some of the leading personalities associated with the London Zoo. Frank Buckland (1826–80), a pioneering authority on fishes and the author of the delightful four volumes of *Curiosities of Natural History*, was an eccentric on the grand scale. This is hardly surprising for his father was Dean of Christ Church and first Professor of Geology at Oxford, where his rooms became a menagerie of unusual animals. It was said that at one time or another he had eaten his way through more than half the animal creation. Ruskin refused an invitation to 'mice on toast', but the Owens, of whom more will be said later, gallantly ate their way through ostrich, which tasted, remarked Mrs Owen, 'very much like a bit of coarse turkey'. Frank Buckland inherited his father's tastes. While an undergraduate he enlivened his academic labours by keeping a bear, which, clad in academic dress, disrupted services in the College chapel. In 1860 he founded an Acclimatisation Society, which aimed at introducing exotic animals and fruits into Great Britain in order to enrich the diet. A dinner of the Society, held in 1862, served such delicacies as Japanese sea-slugs, kangaroo steamer, Syrian pig, botargo, and Chinese yams. But there was also a more serious side to his nature, which was shown in his pioneering work in combating the pollution of Britain's rivers, and in his scholarly treatises on fish hatching. His father's death in 1856 had left him sufficiently well off to follow his own interests, and for more than twenty years his home in Albany Street near Regent's Park became an unofficial hospital for

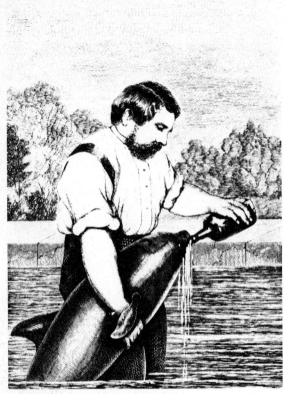

Frank Buckland reviving a porpoise with brandy and water. From *Buckland's Curiosities of Natural History*, third series, vol. II, London 1866.

ailing specimens at the Zoo. Buckland's personality was an endearing one, as a picture of him treating an ailing porpoise with brandy and water touchingly illustrates.

Buckland was a close friend of Abraham Bartlett (1812–97), Superintendent of the Zoo from 1859 until his death, and himself the author of a number of humorous scientific papers. The two men were kindred spirits, and during the years in which Griset knew the Zoo things were never dull.

The arrival of a new species, the birth of a new baby animal, the tragi-comedy of Jumbo and Alice (the elephant sweethearts who were cruelly parted when Jumbo was sold to America), were all followed by an eager press. Such sensational stories demanded illustrations, which in those days before photographic reproduction was perfected, meant work for artists like Griset.

Among the events which he recorded was the *Tremendous excitement at the Zoological Gardens on the arrival of the Penguin*. A dozen king penguins were collected from the Falkland Islands in 1865, but all refused food and died except one which, petted and played with by the sailors, was induced to swallow some fat and fish. Its arrival at the Zoo caused great interest as it was the first example of the species to be seen in this country, and Griset has amusingly captured the circle of eager artists around the bird.

Drawings of this comic potential brought Griset's work to the attention of Mark Lemon, the editor of *Punch*, and the artist was summoned in 1867 to the offices of that journal, an event which he recorded in an entertaining sketch of himself taking off his top hat with a nervous flourish.

One of his first drawings for *Punch*, published on 4 May 1867, is a recollection of one of the most celebrated characters of the Zoo, a French sailor called François Lecomte. Buckland had spotted his unusual act with a sea-lion in January 1866, at Cremorne Gardens, the celebrated pleasure grounds, and had realized its potential attraction as a draw at the Zoo. Lecomte had caught the animal, the first example of its species to reach England, near Cape Horn, and trained it for two years. Its act, carried out with the usual *joie de vivre* of the species, was an immense success, and visitors delighted at its *pas de deux* with Lecomte, drawn by Griset in his invariable costume of striped jersey and French matelot's beret with a pom-pom. He is balancing a fish on the sea-lion's nose, and one can almost hear him say, 'Are you hungry? Here you are, I'll give you a fish'. Lecomte's act deserves to be thus worthily commemorated, for it was the precursor of many delightful sea-lion acts, which are still today, despite the rivalry of dolphins, among the most enjoyable of all Zoo events.

A less happy event was the birth and rapid demise of the first hippopotamus 'Umzivooboo' on 21 February 1871, and the happier outcome of the birth of 'Guy Fawkes' on 5 November 1872, which were all recorded by Griset for *Fun*. In one illustration we see on the left the appearance of the recognizable self-portrait which features in so many of his works, while in another, Darwin, Huxley, Bartlett and Buckland watch excitedly the baby hippo standing on its mother's back.

Post mortems of rare animals were then of great interest, and there was also a demand for casts of unusual specimens. Griset seems to have had access to these somewhat grisly occasions, and depicted, in *Punch, Scientific Celebrities taking the Cast of a Whale* in the Dissecting Room of the Zoological Gardens. Bending down at the whale's head is the unmistakable figure of Buckland, while other celebrities assist in pouring on the plaster, and modelling.

By far the most important scientific figure caricatured by Griset was Sir Richard Owen, the first director of the Natural History Museum, and the coiner of the term 'Dinosaur' from the Greek words for 'terrible lizard'. Owen, like Griset, has sunk like a fossil into the rich seams of Victorian eccentricity. The greatest palaeontologist of his day, but an uncompromising anti-Darwinian, he is best remembered today for the impressive group of life-sized models of iguanodons and brachiosauri which still remain at the site of the Crystal Palace. These cement figures, executed in 1854 to Owen's directions by the sculptor Waterhouse Hawkins, were designed to emerge four times daily, by an ingenious flooding device, from the primeval slime of Sydenham.

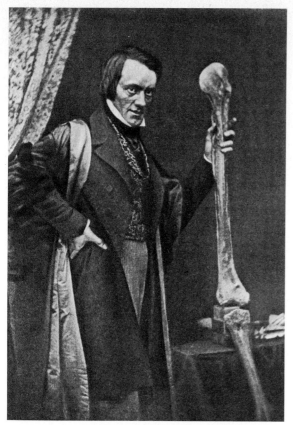

Richard Owen, the greatest palaeontologist of his day and first director of the Natural History Museum.

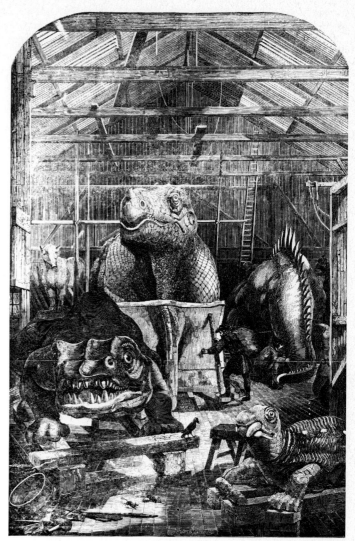

The sculptor, Waterhouse Hawkins, working on the vast cement statues of dinosaurs prior to their erection in the grounds of the Crystal Palace, at Sydenham, where they can still be seen today. *Illustrated London News*, 31 December 1853.

Owen was a caricaturist's dream, with an extraordinary nutcracker face, and a highly developed sense of humour. His own favourite story, told against himself, has a typically macabre twist. As a young medical student at Preston, he had a passion for anatomy. The hospital was situated in the castle at the top of a steep hill. One holiday weekend he took home a negro's head in a carpet-bag to dissect at leisure. He was clad in a long black cloak. It was a cold and frosty night. . . . At the foot of the hill was a cottage in which lived a sea captain's widow and her daughter. That evening they were seated by the fire talking over the dead captain's life, much of which had been passed in the slave trade. . . . Suddenly the door burst open, and in bounced a severed negro's head, followed by a sinister cloaked figure, which glared wildly round the room, bent to retrieve the head, and vanished into the night! In the words of the famous *Punch* caption, 'collapse of stout party'!

Owen's natural exhibitionist streak led him into several situations which provided perfect subjects for Griset. Once, for example, he was summoned by the Prince Consort to Buckingham Palace to examine a giant turtle which had been given to the Royal Family. Owen, a small man, in attempting to measure the girth of the turtle, mounted its shell, and was taken for a ride around the room until he was assisted to dismount by Prince Albert.

Griset revelled in Owen's unquenchable enthusiasm for re-creating extinct creatures from the evidence of small pieces of fossil bone, and giving them jaw-breaking names. In a pair of caricatures we first see Professor Owen seated in his study, receiving a visitor. The caption reads as follows: Owen, 'Hullo!! Bryce-Wright – What a new discovery! Why!! It's a dentigerous bird!! I'll find it a *simple* name say "Odontopteryx Toliapicus".' In the sequel (shown in the colour plate section of this book), the Professor proudly shows his visitor a completely 'restored' bird, reconstructed on the slender evidence of the fossil beak.

While he delighted in depicting such glimpses of behind-the-scenes scientific activities, Griset found the task of adapting his highly original talents to the exigencies of producing several weekly caricatures for *Punch* much less congenial. He made valiant efforts to

follow in the footsteps of Doyle's celebrated *Foreign Tour of Brown, Jones and Robinson* with some fifteen weekly episodes of a caricature series entitled *Our Artist in Paris* but with rather uninspiring results. He also produced a number of inventive initial letters, which have been used throughout the present book. According to M. H. Spielman's *History of Punch*, Mark Lemon cooled towards Griset, and one can well imagine why, for it is difficult to imagine Griset fitting in at the convivial evenings around the celebrated *Punch* table. After two years of intensive work, and still only twenty-six years of age, Griset left *Punch* in 1869.

One of the reasons for his inability to produce his best work for *Punch* may have been the sheer quantity of books which he was also illustrating during these busy years. He had no less than eight commissions in two years, as well as work for other periodicals. The books included some of his finest work, *The Purgatory of Peter the Cruel* and *Griset's Grotesques*, produced in collaboration with James Greenwood and Tom Hood respectively, and are more fully discussed in the next chapter. But his illustrations to three popular classics with themes particularly suited to his talents, *Robinson Crusoe*, *Aesop's Fables*, and *Reynard the Fox*, are less successful, partly because of the methods of reproduction employed. The work of Gustave Doré was then enjoying a great success, his illustrations to such books as *Milton*, *Don Quixote* and *London* being much admired for their powerful imagery and rich chiaroscuro effects. Doré's bold style was perfectly adapted for translation by the virtuoso interpretative skills of wood-block engravers like the Dalziel Brothers. But more sensitive artists dreaded the adaptation of their line or wash drawings to suit the dense black effects of the wood-block, which had a deadening, though dramatic effect, eliminating the quality of delicate draughtsmanship. Rossetti execrated the process in the celebrated lines

> *Oh woodman spare that block!*
> *Oh wrought not anyhow*
> *It took two days by clock*
> *I'd feign defend it now.*
> *(Chorus: wild laughter from the Dalziels' workshop)*

Griset's essentially linear style suffered badly from such a process and the demands it created, as can be seen if the original watercolour for *Grace before Meat* is compared with the crude published interpretation of the drawing in *Little Folks*.

In the early 1870s Griset married a lady named Laura, who may, so family tradition has it, have had some connection with the family of John Foley, the sculptor of the statue of Prince Albert and of the 'Asia' group on the Albert Memorial. She was six years Griset's junior, having been born in 1849. It seems to have been an extremely happy marriage, one daughter recalling regular visits to the Zoo, and the presence in the family home of a large and varied collection of unusual animal pets. But the steady arrival of children, eventually to number thirteen, must have placed a strain on Griset's artistic capacity for work. He turned more and more to regular work for such forgotten magazines as *Good Words for the Young*, *Little Folks* and *Good Things* and to the illustration of children's annuals. As a result his name, so familiar in the 1860s, sank, with amazing swiftness, into oblivion.

In July 1877, a number of appreciative obituary notices of the late Ernest Griset were published. *The Publisher's Record* perceptively memorialized the fact that 'Griset was very happy in illustrating the Darwinian change of an animal into a man, and of combining men and animals, something after the manner of Grandville. He was quite French in his manner, though he had lived in England from early boyhood. He was very grotesque . . . his death should be a loss to real caricature and comic art. . . .' *The Athenaeum* recorded his 'first public appearance . . . exhibiting pen-and-ink sketches in a little shop near Leicester Square, which he produced with marvellous rapidity, and which have so much wit, vivacity and humour that they will some day be of great value', while *The Times* commented favourably on the satirical nature of his work, and the expressive quality of his line.

These obituaries, particularly the one that acutely compared his work with Grandville's, the creator of the splendid gallimaufry of beasts in *La Vie Privée et Publique des Animaux*, were all both complimentary and accurate. They erred in only one respect – the artist was still very much alive. On 31 July 1877, in order to contradict these rumours, Griset circulated the following letter:

Dear Sir,

In case you may have seen the false report of my sudden death in the *Times* and *Athenaeum* I am happy to say there is no foundation to this statement, never having been in better health, and that I am always at your orders. I remain,

Yours very truly,
Ernest Griset.

The somewhat mixed pleasure of reading your own obituary is given to few, and Griset, it is to be hoped, was not too dissatisfied with these critical evaluations of his career. He would certainly have been less pleased with his real obituary notices thirty years later, or rather the surprising lack of them, for in those decades his name had become virtually completely forgotten. He still found regular outlets for his work in *The Boy's Own Paper* and *The Girl's Own Annual* and illustrated three stories by a patron and friend, Lord Brabourne. But his own interests turned more and more to prehistoric times and themes as, perhaps, an escape from the harsh realities of trying to scrape a living in relatively low-paid publications. In these prehistoric paintings, most of which are of considerably larger size than his earlier work, his palette becomes harsher and more strident in colour, and his use of gouache and oil thicker with a somewhat unpleasant impasto. An unexpectedly cruel element

becomes apparent in some of his scenes of dinosaurs in conflict, and of birds of prey savaging their victims.

He died at Highgate on 22 March 1907. An obituary notice in a local paper reads:

'A FORGOTTEN ARTIST.

Mr E. H. Griset recalled to mind by Death.

A pathetic instance of the uncertainty of fame is provided by the death of Ernest Henry Griset, the once famous London artist, who will be buried in Finchley Cemetery tomorrow afternoon.

Thirty years ago it was reported that Mr Griset, who was then at the height of his renown, was dead and many believed it. It came, therefore, as a double shock to those who dimly recollected his work to learn of his sudden death from heart failure outside his house at Highgate.

It was only the publication of the report of the inquest at the St Pancras Coroner's Court that recalled Mr Griset's name from the past, although at the time of his death he was only in his sixty-fourth year, and much of his best work had been done after London had forgotten him. . . .

He was happiest when he was at work in the Zoological Gardens.' These words could almost serve as Griset's epitaph.

'Always at your Orders'

he phrase 'I am always at your orders', from his letter rebutting the erroneous notice of his death, can well stand for the busy pattern of Griset's life as an illustrator. The impression is gained from the long list of publications illustrated by him (see Bibliography) that he never refused a commission, whether congenial to his talents or not. Like the theatrical profession, the career of a caricaturist is vitally dependent on always keeping 'one's name before the public', and Griset in this respect was assiduous in keeping up a steady output of work. Besides regular contributions to such periodicals as *Fun, Punch, Little Folks*, and latterly *The Boy's Own Paper*, during the forty years of his active career he illustrated more than twenty books in addition to painting large numbers of straightforward water-colours.

He was unfortunately not blessed in his principal collaborator, James Greenwood, of whom even less is known than of Griset. Greenwood, who can be seen on the right of the frontispiece of their first collaborative venture, *The Hatchet Throwers* (1866), had a singularly unfunny and unpleasant sense of humour, even by late Victorian standards. It is difficult not to agree to some extent with the admittedly pompous review of their first work, *The Hatchet Throwers*, in *The Athenaeum*: 'We fail to perceive any drollery in this dismal book, the illustrations whereof match the letterpress. There may be some covert meaning in the professed fun, which it is reserved for greater wits than ourselves to discover. It comes, moreover, at an unfortunate time when we are not disposed to consider the relations of the black and white races as a joke. One merit, however, the volume professes, it is handsomely printed.' Whilst the racialist content of the illustrations would make the book a subject for the attention of the Race Relations Board were it published today, it is possible, if we think ourselves back in time to 1866, to sympathize with the irritation that this review aroused in Griset. He was goaded into writing a letter of protest to *The Athenaeum*, which was not published by that journal, and into producing an amusing caricature of the reviewer. Under it Griset wrote, 'Fancy portrait of the "dismal" writer of the annexed notice from *The Athenaeum*, who, labouring under an attack of colic, could not see what there is in *The Hatchet Throwers*, but will see what there isn't. The writer confesses himself, however, no great wit.' To console himself Griset pasted on the same sheet some other reviews of the book which were, on the whole, most favourable. *Lloyd's Weekly Newspaper* wrote: 'This artist has long delighted the Londoners who have been wont to pass his little shop-window by Leicester Square, and they had wondered when he intended to issue from his obscurity – for Ernest Griset is a caricaturist of the highest, the richest order.'

The most perceptive review, that from *The Daily Telegraph*, provides an acute appraisal of the role of James Greenwood in the creation of the book: '*The Hatchet Throwers* by James Greenwood is a vehicle for the humorous draughtsmanship of M. Ernest Griset, a young and extremely promising French caricaturist, and as a vehicle the work on the author's part possesses all the requisite vehicular qualities; that is to say, it is well-built, it is well-balanced; and it runs very evenly, smoothly and pleasantly along.

'M. Griset seems to have read books of travel through the distorting lens of a grotesque imagination, and to have studied animal life in the sober spirit of a savant. The blending of wild, reckless comicality with physiological exactitude, produces a new kind of fun which might be cultivated with a continuing and increasing success the more especially if M. Griset would give the same attention to human figures which he has evidently bestowed on all varieties of birds and beasts, fostered by the Zoological Society and stuffed by the authorities of the British Museum.' This is an extremely pertinent piece of criticism, which, rather uncannily, exactly prophesies the future pattern of Griset's career, for it accurately draws attention to the weak chink in his armour as a caricaturist, his relative lack of interest in human, as opposed to animal, subject material. In nearly all his work the primary position is occupied by an animal, with man as a supernumerary (the recording artist or photographer is a recurrent theme), or else providing a note of menace. When required to produce solely human subjects, Griset takes refuge either in a

fantastic medieval style, ultimately derived from the work of Jacques Callot, or in rather heavily burlesqued comic types, like the Brothers Brass in *The Hatchet Throwers* (later re-used as *The Brothers Bold*), often derived and evolved from his compulsive urge to produce self-portrait caricatures.

The Daily Telegraph reviewer's accurate description of James Greenwood as a vehicle writer perfectly adapted to Griset's needs, makes one long to know more about the exact nature of their collaboration, particularly in the creation of Griset's masterpiece, *The Purgatory of Peter the Cruel*, published in 1868. The singularly unpleasant story is concerned with the various metamorphoses that befall a cruel little boy named Peter, who tortures and maims a beetle, a bluebottle fly, a snail, an ant, and a newt, and is successively transformed into the bodily form of each of his victims as a purgatorial punishment. This grisly story undoubtedly fits Griset's brilliantly sympathetic observation of insect life to perfection, and one cannot help wondering about the extent to which he himself helped to formulate the story. Perhaps the most successful of all the states Peter passes through is his adventures as an ant, notably the scene in which he is set to work milking the aphis cows, whose milk is prized by the ants as nectar.

While it is therefore probably unfair to blame Greenwood completely for the heavy humour of his texts, it is undoubtedly true that the books are only redeemed and remembered today by Griset's illustrations. The work of Tom Hood, his other chief early collaborator, still has, however, at its best, some appeal to contemporary taste today. Hood wrote the jolly jingles that accompany the illustrations of *Griset's Grotesques*, published in 1867:

> *Sky-scraper,*
> *Oh, law!*
> *Long paper*
> *If I draw!*
>
> *Progress slow,*
> *By degrees!*
> *'Tishoo!' Oh*
> *What a sneeze!*
> *On the sly,*
> *Paper peppered.*
> *Good bye,*
> *Camelopard!*

'The Hog Family. An operetta for the Drawing Room' could indeed still provide an acceptable script for Miss Piggy in *The Muppet Show*.

It can fairly be deduced that Griset's illustrations almost in every case gave rise to the poems, rather than the other way round. This is clearly shown by the series of drawings which show sailors, seals and a walrus. It would appear probable that Hood looked at these in some perplexity until, in desperation, he came up with the poem 'The Frozen Phantoms'.

Hood was also responsible for some of the most successful of the poems illustrated by Griset in *Fun*:

'Saturday Night', 'Our London' and 'The Lord Mayor's Show and Dinner Combined'. Such tailor-made themes brought out the best in Griset who produced, to accompany the verses, what might be described as an anthropomorphic parallel to Henry Mayhew's *London Labour and the London Poor*. The strange images of *Our London* in particular have a weird fascination, for they combine Griset's daily observation of the street-life of London, with its drunks and coffee stalls, with his obsessive urge to convert everything he saw into animal terms.

This process can be seen in action in four related drawings of buses. Griset must have known such vehicles well, for they were the main means of transport in Victorian London. We can in imagination accompany him on his busy daily round of visits to the offices of various publishers, the Zoo and meetings of the Zoological Society. Characteristically, Griset has both drawn this subject as he observed it in his daily round, in two lively impressionistic sketches of the inside and outside of a bus, and used the same idea for one of his anthropomorphic scenes in *Our London*. Such sketches reveal, more clearly than any of his other work, the similarity of Griset's imaginative processes to Grandville's. Of Griset, as of Grandville, one could say in Baudelaire's words: 'This man, with superhuman courage, spent his life in rebuilding creation. He took it in his hands, kneaded it, rearranged it, explained it and commented on it. . . . He turned the world upside-down'.

In collaboration with Hood and Greenwood, Griset produced some of his best work in the years of his early success between 1865 and 1870. But after that date, as the dust of Darwinian controversy settled, he became less in demand, and correspondingly less free in the choice of his subject matter. He had to accept more and more work for periodicals, and in particular for children's magazines like *Little Folks*. It is almost certain that for many of his contributions to this paper, such as *The Beetles' Banquet*, Griset turned author and wrote the accompanying text to go with his pictures. Griset's contributions to *Little Folks* in the 1880s retain all his inventive powers, a splendid example being *Mrs Grasshopper's Tennis Party*, a return to the theme at which he so excelled: the depiction of insect life.

As the busy years rolled by he became increasingly dissatisfied with the constant pressure involved in the production of weekly magazine copy and illustrations. His work, while always original and entertaining, inevitably became somewhat repetitive. As an escape, he turned with more and more pleasure to the straightforward depiction of animals at the Zoo, making numerous studies of species as varied as the giraffe, arctic wolf, tawny owl, brown bear, and including an engaging study of a chimpanzee with pipe, tobacco and matches. But unfortunately for him there was just too much competition in this field to enable him to make a decent living out of such productions. Joseph Wolf, the most prolific of all

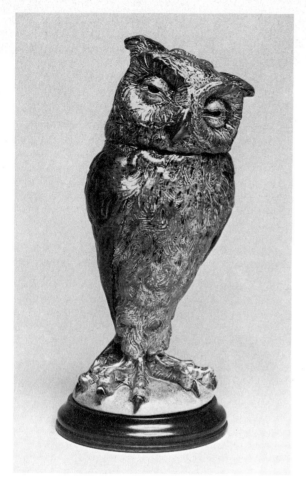

Salt-glazed figure with movable head, modelled by Robert Wallace Martin, in 1899. 29.2 (11½). By courtesy of the Victoria and Albert Museum, London.

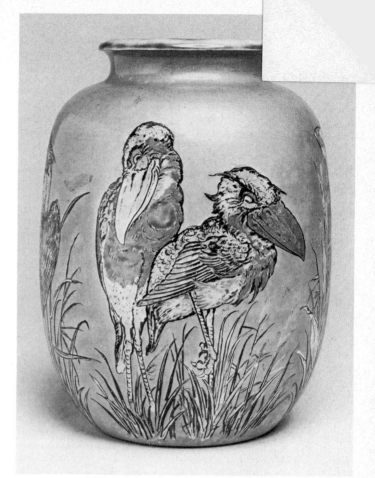

Grotesque birds. Incised decoration on pot by Edwin Martin. 1902. 20.3 (8). By courtesy of the Victoria and Albert Museum, London.

zoological artists, whose illustrations virtually monopolized the pages of the *Proceedings and Transactions of the Zoological Society* throughout Griset's career, was only one of a host of animal artists who literally swarmed about the Zoo.

This lack of success, and a sense of frustration, are reflected in the unexpected note of savagery that creeps into some of his work for the *Boy's Own Paper* during the last years of his career. He contributed to it a number of plates reproduced in colour of birds and animals of prey engaged in tearing their victims to pieces.

Dissatisfied, Griset turned again to an old interest in prehistoric themes. Such subjects lent themselves, because of the vast scale of the dinosaurs, to expression in the bolder medium of gouache and oil paint, a change which Griset welcomed after years of application to the exacting disciplines of the woodblock, and watercolour painting.

According to the Dalziel Brothers, he also began to try his hand at the decoration of public halls. A group of large gouaches which date from these years and may well have formed a decorative ensemble, record a vision of prehistoric life as disturbing as that described in Conan Doyle's novel *The Lost World*.

They include representations of hairy mammoths lost in the snow; a wildly inaccurate depiction of the gentle plant-eating brontosaurus fighting a crocodile; an over-lifesized painting of a *very* primitive man; and a group of glowering ancient Britons. He also painted several variations on the theme of cave men setting up home in the vast skeletons of dinosaurs, using their rib-cages as roof-struts, and their bones as props for washing-lines.

Griset had always loved painting cranes and storks, revelling in the shaggy, hunched formation of their necks and backs, and in their long necks and beaks. Their disconcertingly interrogative gaze and knowing tilt of their heads provokes an unconscious smile without recourse to parody. It is highly probable that the Martin Brothers, the Southall family of potters, knew and appreciated Griset's depiction of this species, for among the debris on their studio floor was the frontispiece to *Griset's Grotesques*, pinned up as a visual *aide-memoire*. There is certainly a strong resemblance between Edwin's stork drawn on the side of a pot, and Griset's treatment of the same bird. This is also true of Robert Wallace's birds which have what can be described as a family resemblance to Griset's sketches. The point should not be overlaboured as

Martinbirds are a highly original species of grotesque art in their own right, but it is an intriguing comparison.

The same can be said of the remarkable taxidermic tableaux of Walter Potter (1835–1918) of Bramber in Sussex. Such groups were pioneered by the German taxidermist Ploquet, whose barber's shop of stuffed frogs so impressed Queen Victoria at the Great Exhibition in 1851. Potter's development of such themes in the 1870s and 1880s produced the memorable groups of *The Rabbits' Village School, The Guinea Pigs' Cricket Match,* and *The Kittens' Wedding,* in which, as in Griset's drawings, the animal world mirrors the daily routine of human experience.

What these men shared to a certain extent with Griset was his remarkable ability to be, as it were, on both sides of the bars of any cage at one and the same time, aware of the humorous behaviour of both men and animals alike. This sympathy is seen at its best in the themes to which he returned again and again, of the struggles of artist and photographer attempting to portray an animal on canvas or negative. For Griset the humorous possibilities of this situation never palled, as his own experiences had given him innumerable examples of how ridiculous it could be for both man and animal.

Like his anti-hero, Peter the Cruel, Griset could, in imagination, leave his human body, and wriggle into and out of one animal's skin after another. In so doing, his opinion of the cruelty and stupidity of his own species, *man,* became at times savagely critical. Such an attitude is revealed in his variations on the theme of the last book of *Gulliver's Travels: Dobbin – Horses* from *Our London* in *Fun.* The text accompanying the illustrations has the same disgust at man's cruelty to animals as Anna Sewell's classic *Black Beauty,* and it would seem highly probable that it is, in part at least, Griset's own work.

One cannot imagine Griset in a heaven without animals, so let us conclude by using Buckland's last words, which are equally suitable for his friend Ernest Griset, 'I am going a long journey where I think I shall see a great many curious animals. This journey I must go alone.'

Touché! Two stuffed squirrels by Walter Potter. By courtesy of Potter's Museum, Arundel.

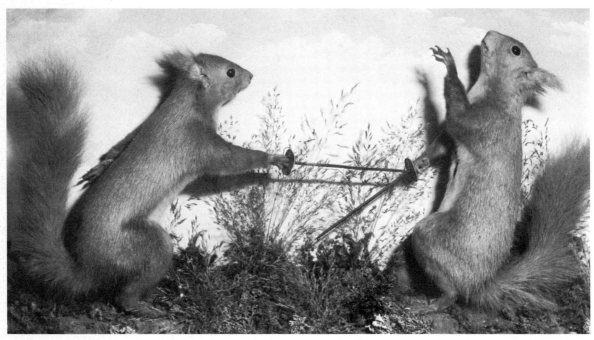

CAPTIONS TO COLOUR PLATES (PAGES 17–20)

I A caricature depicting Professor Richard Owen and a Mr Bryce-Wright. The latter discovered, in 1873, the head of a dentigerous bird. Professor Owen named this *Odontopteryx Toliapicus.* Pen, ink and watercolour. 22.8 × 30.4 (9 × 12). By courtesy of the Victoria and Albert Museum, London.

II *Sleeping Lion.* Black chalk and watercolour. 43.1 × 76.1 (17 × 30). By courtesy of the Victoria and Albert Museum, London.

III *Tawny Eagle.* Water- and body-colour. 52.6 × 39.6 (20¾ × 15⅝). By courtesy of the Victoria and Albert Museum, London.

IV *Affecting farewell. The Crab Pot.* This watercolour was inspired by the obituary notices which appeared in July 1877, reporting Griset's death. He was very much alive at the time and circulated a letter denying the report. Pen, ink and watercolour. 21.6 × 17.1 (8½ × 6¾). By courtesy of the Victoria and Albert Museum, London.

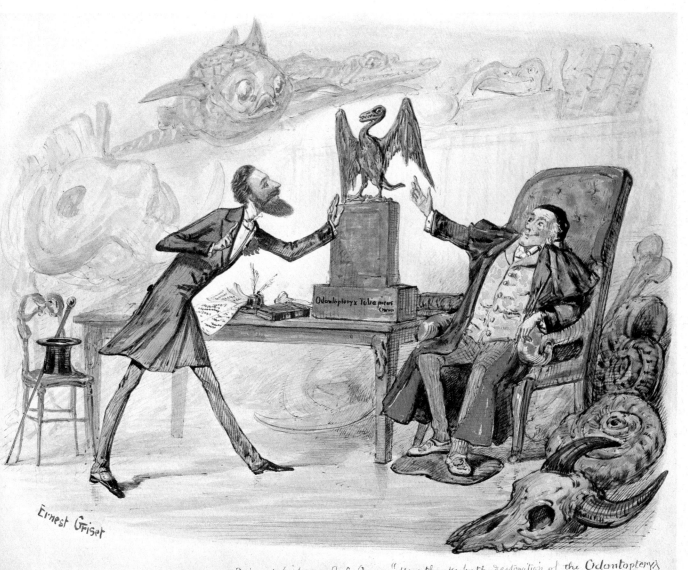

Ernest Griset

Bryce-Wright to Prof. Owen "Many thanks for the restoration of the Odontopteryx Toliapicus!"

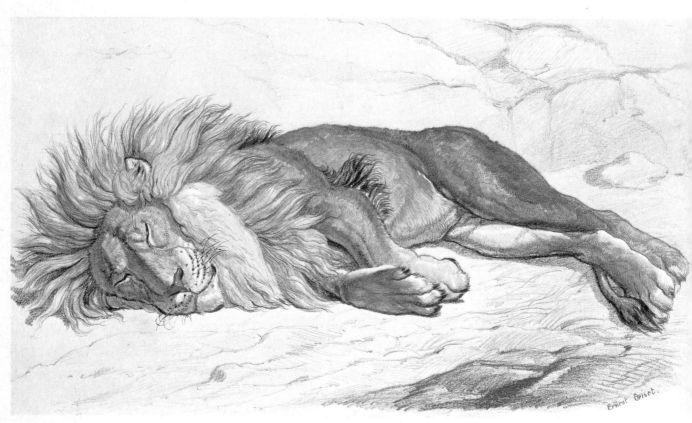

II

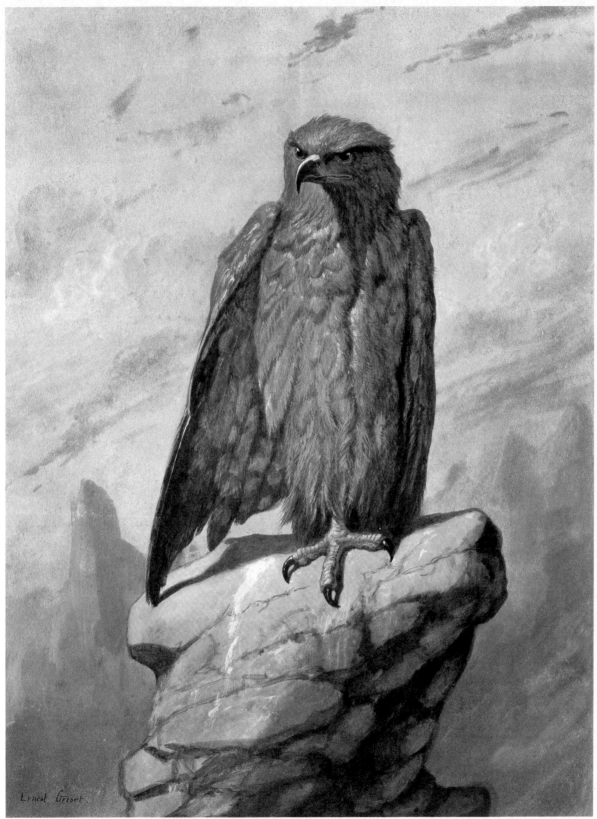

III

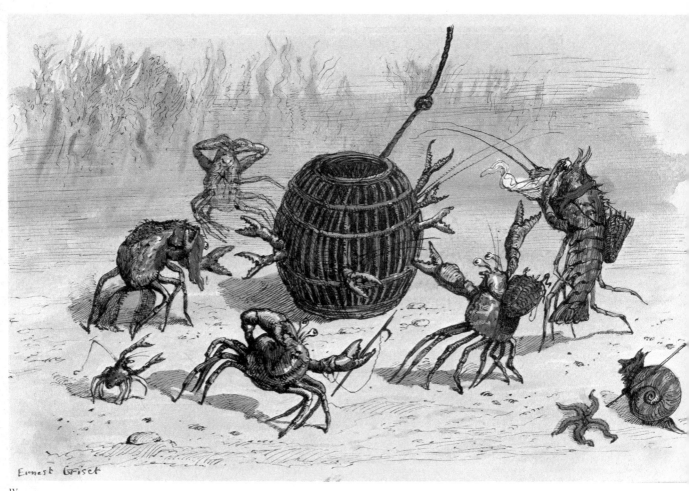

IV

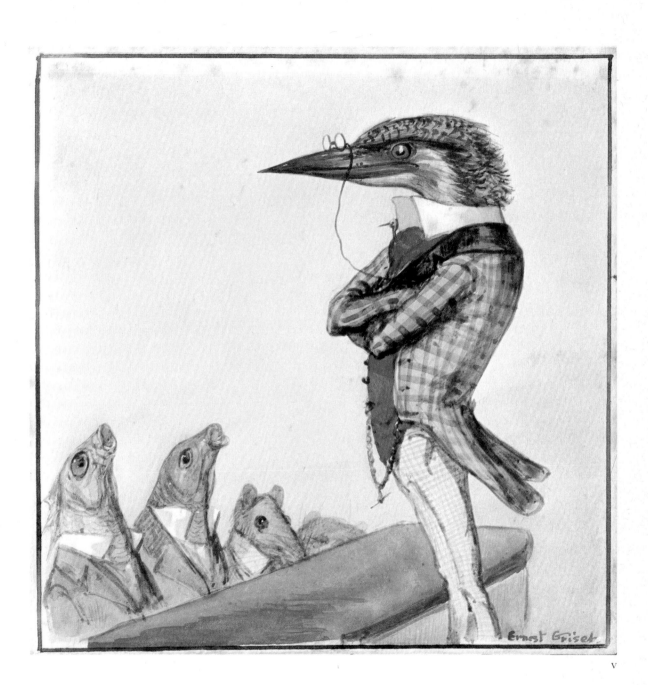

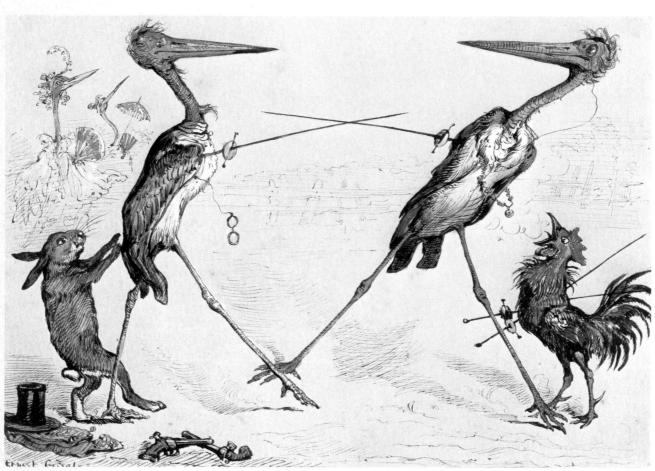

VI

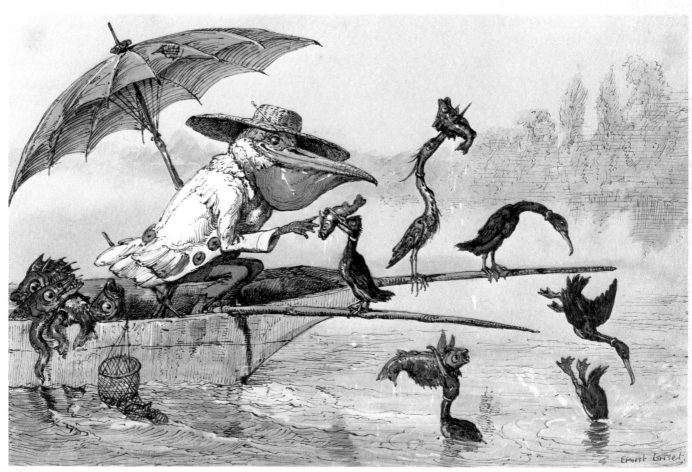

VII

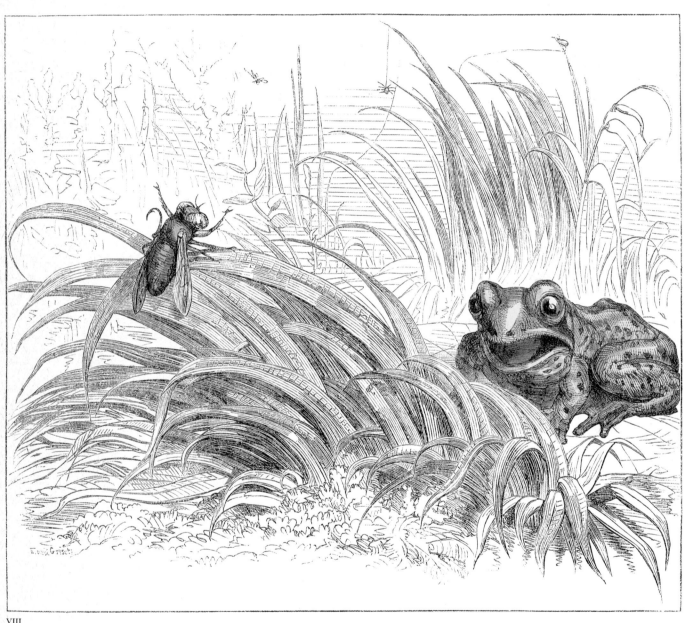

VIII

Griset spent most of his life in Highgate and Kentish Town, within easy reach of the Zoo, which he visited frequently for inspiration. His caricatures provide enlightening glimpses behind the scenes. We see zoological personalities like Frank Buckland and

Professor Owen presiding over such grisly activities as the dissection of a kangaroo, or the making of a plaster cast from a dead whale. Griset also recorded the arrival of the first penguin and the first sea-lion act.

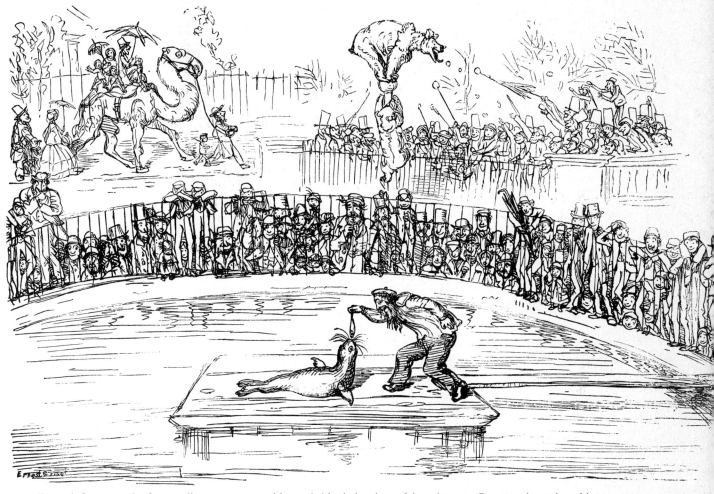

François Lecomte, the first sea-lion tamer, teases his protégé by balancing a fish on its nose. One can almost hear him say, 'Vous avez faim? Je vous donnerai un poisson, voilà!' *Punch,* 4 May 1867.

CAPTIONS TO COLOUR PLATES (PAGES 21–24)

V Griset probably took this theme, a kingfisher lecturing to a private audience of fish, from Grandville. He was always short of money and used the cheapest possible paper, which, as in this example, tended to discolour. Watercolour. 19.15 ($7\frac{3}{4}$) square. From the collection of John Lewis.

VI *The Rivals.* A duel between two storks. Pen, ink and watercolour. 17.8×26.6 ($7 \times 10\frac{1}{2}$). By courtesy of the Victoria and Albert Museum, London.

VII *The Dream of the Fisherman.* A lazy pelican employs cormorants to do his fishing for him. Pen, ink and watercolour. 16.8×26.6 ($6\frac{5}{8} \times 10\frac{1}{2}$). By courtesy of the Victoria and Albert Museum, London.

VIII 'The Indian Frog is Amazed at Sight of a Fly of the Hook-Back Species'. The cruel boy, Peter, has been changed into a fly, and has to escape the clutches of a hungry frog. *The Purgatory of Peter the Cruel* by James Greenwood, London 1868.

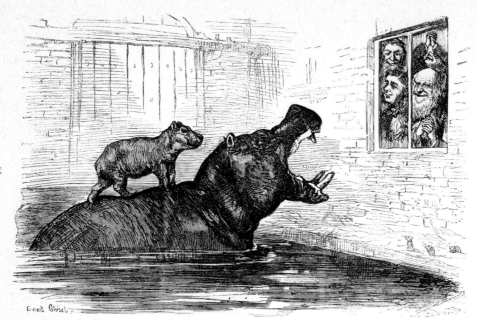

Four scientific worthies, Darwin, Buckland, Bartlett (the Director of the Zoo) and Professor Huxley, watch excitedly as the first baby hippopotamus, 'Umzivooboo', stands on its mother's back. *Fun*, February 1871.

Centre, left, 'But these were the real mourners . . .'. 'Umzivooboo' mourned by his mother and by Griset. *Fun's Comical Creatures*, London 1884.

Centre, right, 'The Baby Hippopotamus. Art and Literature were largely represented at the post-mortem.' A gleeful examination of the dead infant by artists and natural historians. *Fun's Comical Creatures*, London 1884.

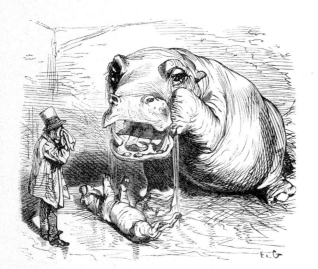

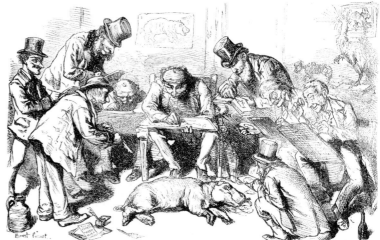

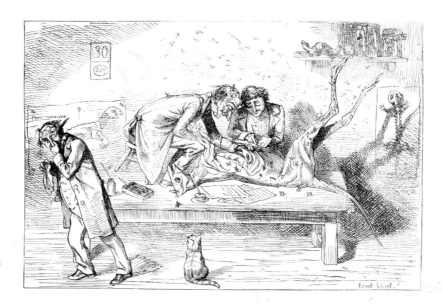

This drawing of the dissection of a kangaroo was published in *Fun's Comical Creatures*, London 1884.

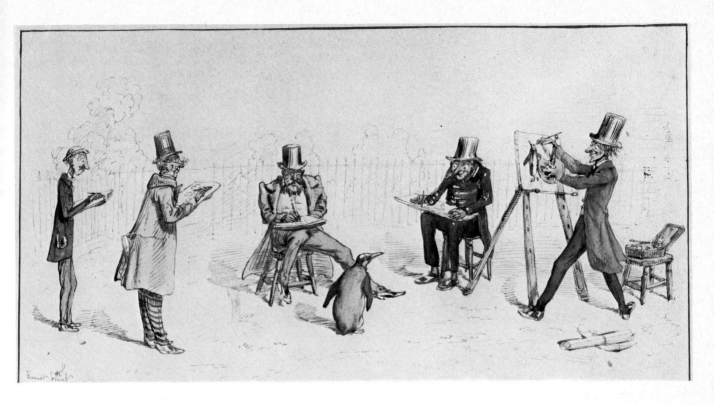

Above, the first live penguin to arrive at the Zoo caused great public interest in 1865. Watercolour. 22.8 × 43.1 (9 × 17). By courtesy of the Victoria and Albert Museum, London.

Below, scientific celebrities taking the cast of a whale in the Dissecting Room of the Zoological Gardens. *Punch*, 25 May 1867.

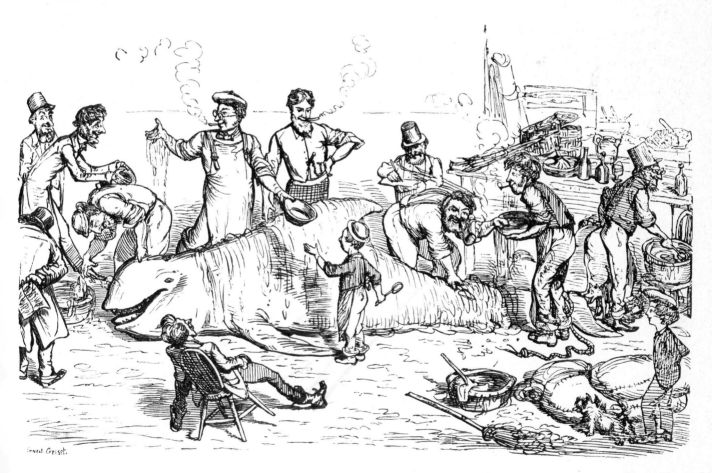

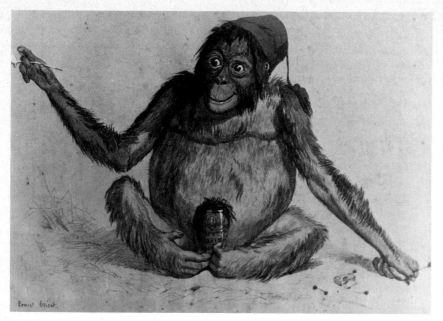

Henry Old Gold. One of Griset's most delightful watercolours, now in the possession of the artist's grandson, Ernest Knight. 35.5 × 53.2 (14 × 21).

It is interesting to compare this dancing hippopotamus with the hippopotami in Disney's *Fantasia*. Griset's drawing comes from one of his later books, *A Child's Dream of the Zoo* by William Manning, London 1889. The story was also available as a series of dissolving views (the Victorian magic lantern show which could be called a forerunner of the animated cartoon).

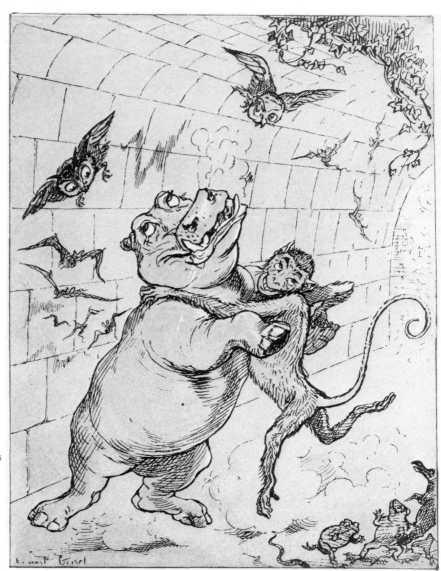

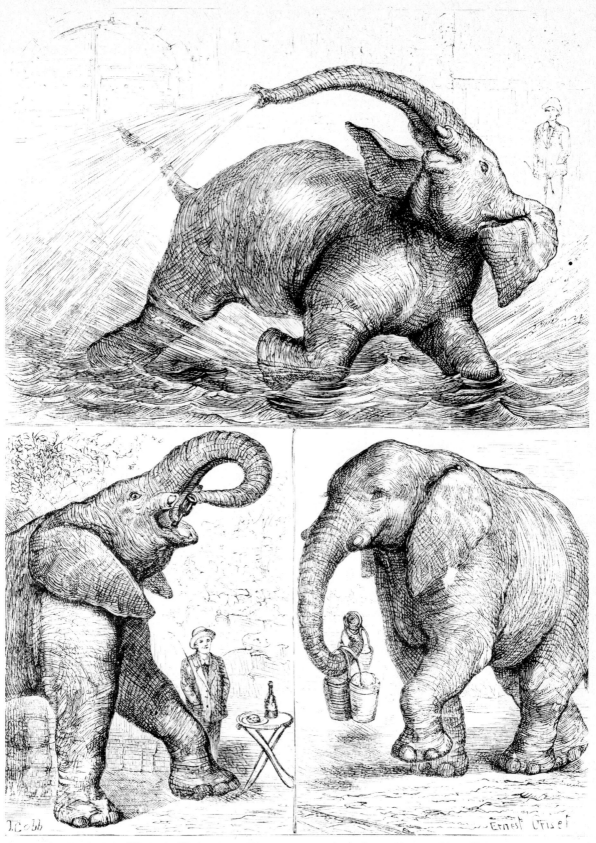

Scenes in the Life of Jumbo. 'His bath. His luncheon. His dinner'. Jumbo, a rogue elephant, savaged his keeper. The Zoo authorities sold him to the American showman P. T. Barnum, despite the fact that Jumbo's 'wife', Alice, was in an 'interesting condition'. This callous act outraged the British public, including Queen Victoria, but protests were in vain. Jumbo's skeleton is now in the New York Natural History Museum. *Little Folks*, 1882.

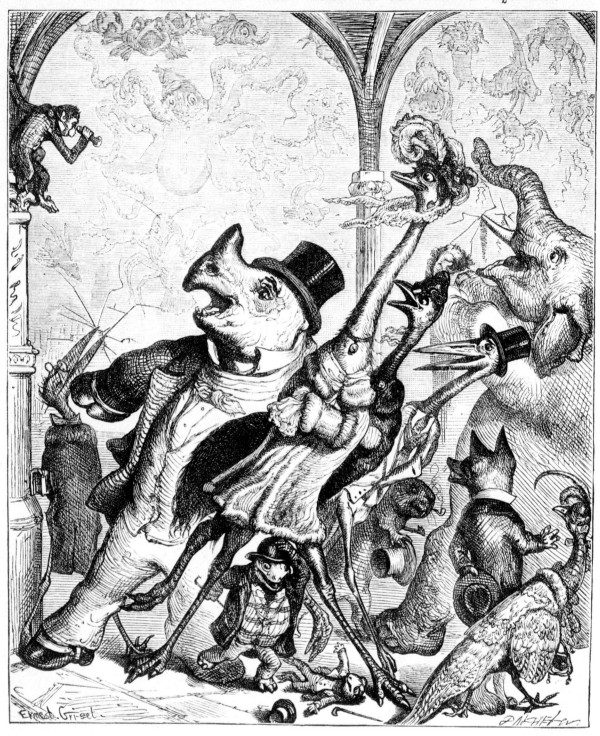

The birds at the Zoo, and the animals, who
 Were feeling existence monotonous,
Exclaimed on a day, in a general way,
 'We want some amusement, the lot of us:

The lives that we cull are deplorably dull,
 We want some excitement to vary um:
A very fine day! Well, what do you say,
 Let's visit the Royal Aquarium.'

Hood's Comic Annual, 1882.

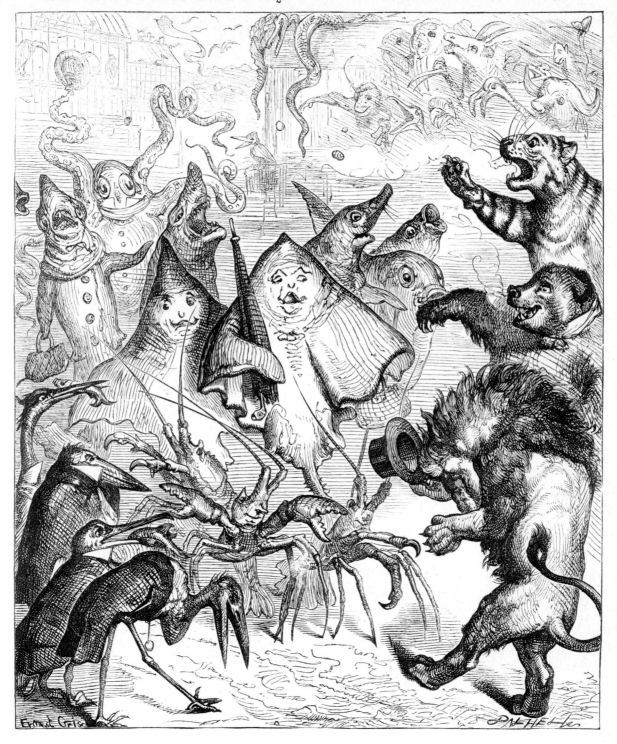

The visit was paid, and the fishes, afraid,
 Accepted the favour with deference;
Although, from their mien, it might plainly be seen
 They'd had given their absence the preference.

When the visitors fled, why, the fish up and said,
 A title to wisdom thus earning it,
'It's not worth a cuss, is this visit, to us,'
 And proved it at once – by returning it.

Hood's Comic Annual, 1882.

31

Observations of a Naturalist

Griset's straightforward studies of animals and birds, a great contrast to his anthropomorphic caricatures, can be compared not unfavourably with the work of his great contemporaries, Edward Lear and Joseph Wolf, who illustrated the classic volumes of John Gould, and the *Papers of the Zoological Society*. There was a great demand for such studies in the days before colour photography. Griset's comic drawings owe much of their strength to these direct observations of bears, lions, giraffes, birds of prey, wolves and, his favourite birds, the storks.

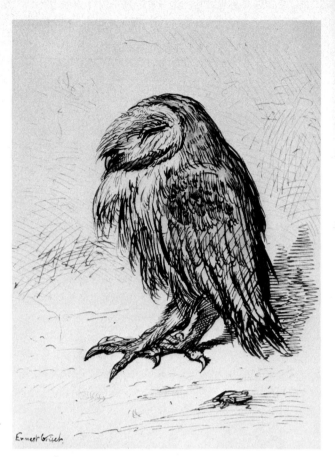

Right, owl. Pen, ink and watercolour. 22.5 × 17.4 ($8\frac{7}{8}$ × $6\frac{7}{8}$). By courtesy of the Victoria and Albert Museum, London.

Below, wolf. Black chalk and watercolour. 38 × 60.2 (15 × $23\frac{3}{4}$). By courtesy of the Victoria and Albert Museum, London.

Opposite, marabou stork. Black chalk and watercolour. 43.1 × 76.1 (17 × 30). By courtesy of the Victoria and Albert Museum, London.

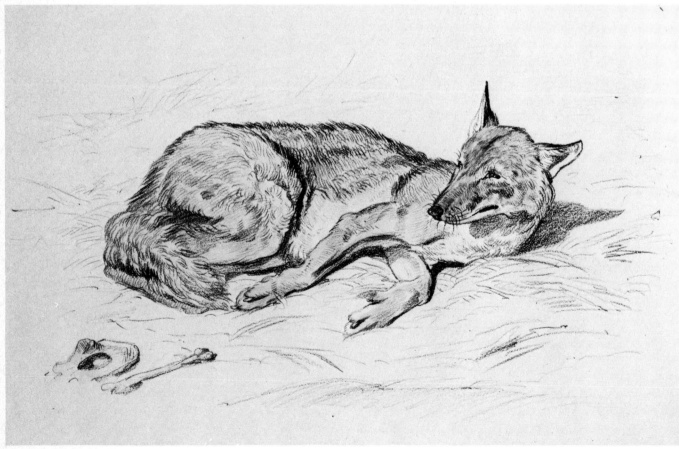

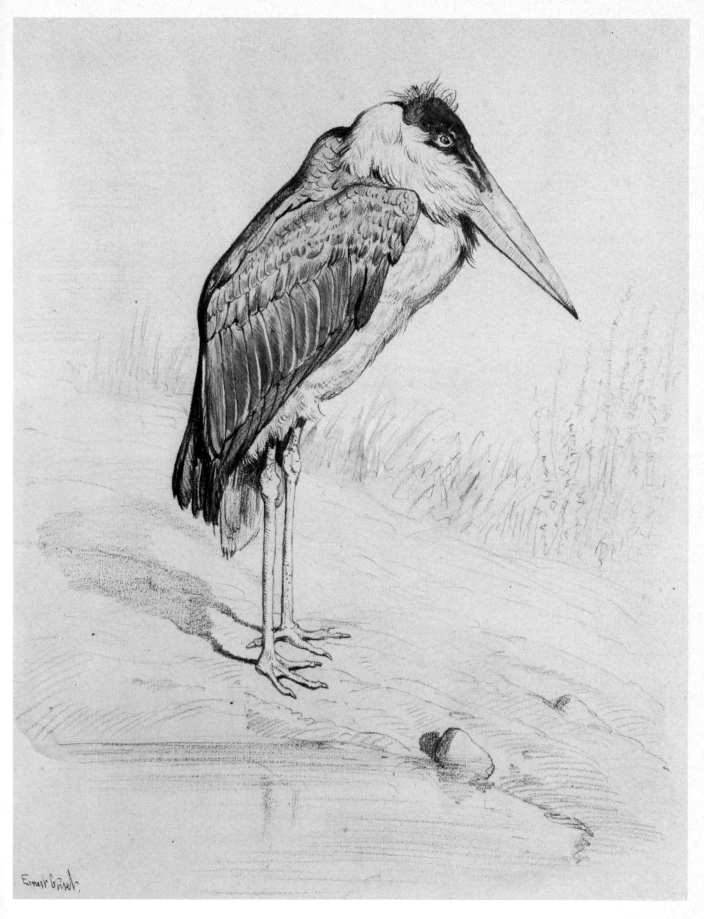

Ernest Griset.

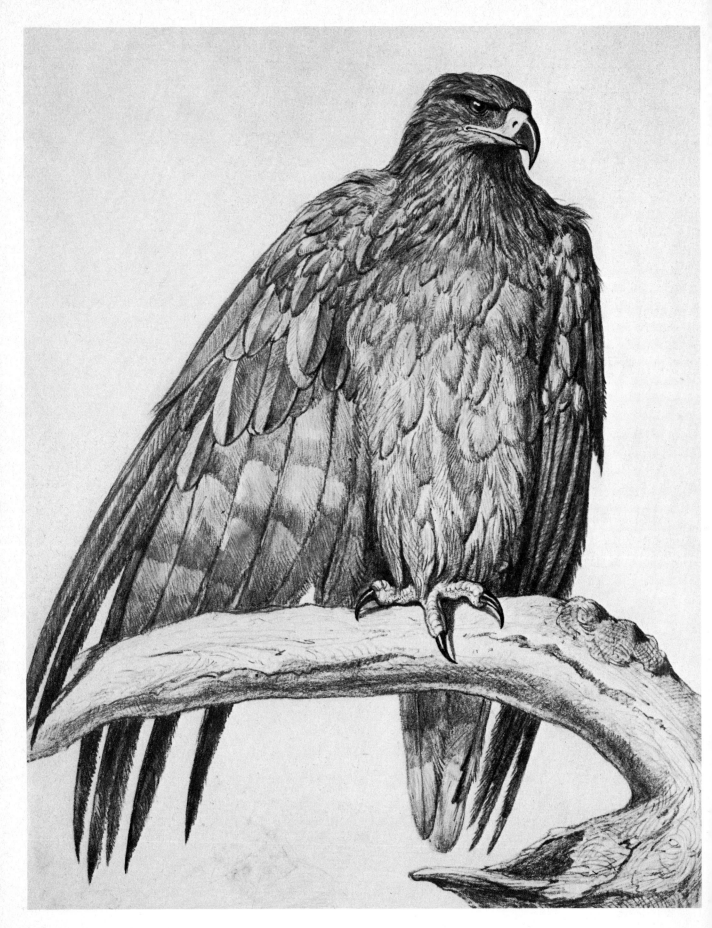

34

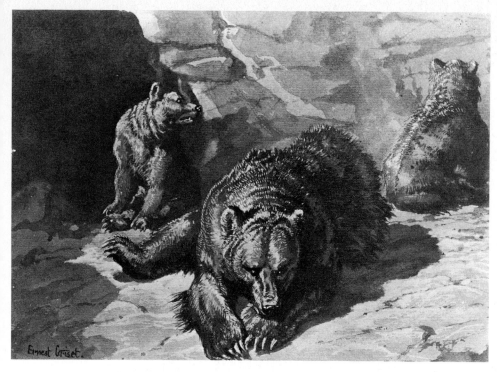

Opposite, tawny eagle. Black chalk and watercolour. 43.1 × 76.1 (17 × 30). By courtesy of the Victoria and Albert Museum, London.

Left, brown bears. Gouache. 15.2 × 21.6 (6 × 8½). By courtesy of the Smithsonian Institution, Washington D.C., USA.

Below, stork. Gouache. 15.9 × 21.6 (6¾ × 8½). By courtesy of the Smithsonian Institution, Washington D.C., USA.

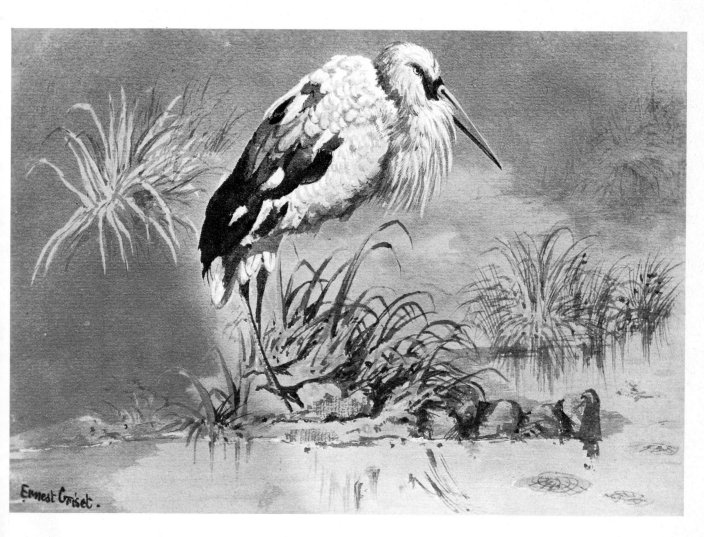

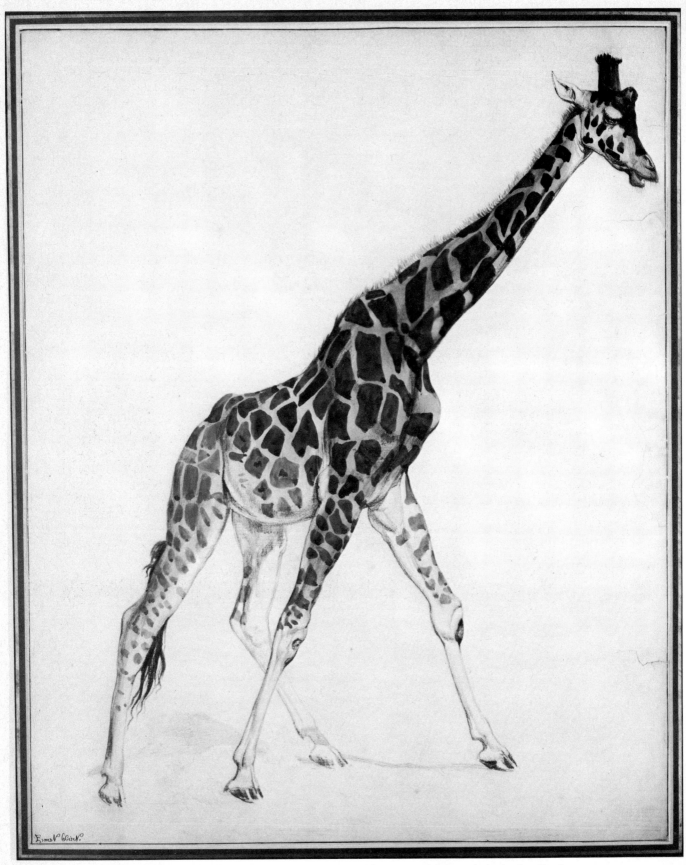

Giraffe. Chalk drawing heightened with wash. 71.2 × 55.8 (28 × 22). Author's collection.

Griset was fascinated by the theme of an artist recording an animal with paintbrush or camera, and the complications caused by the mutual curiosity of both parties. These caricatures possess a remarkable quality of detachment – Griset seems to enjoy the ridiculous aspects of both man and animal. The complicated process of photography in the mid-Victorian era also amused him and he loved to picture monkeys and other animals investigating the camera and hampering the photographer.

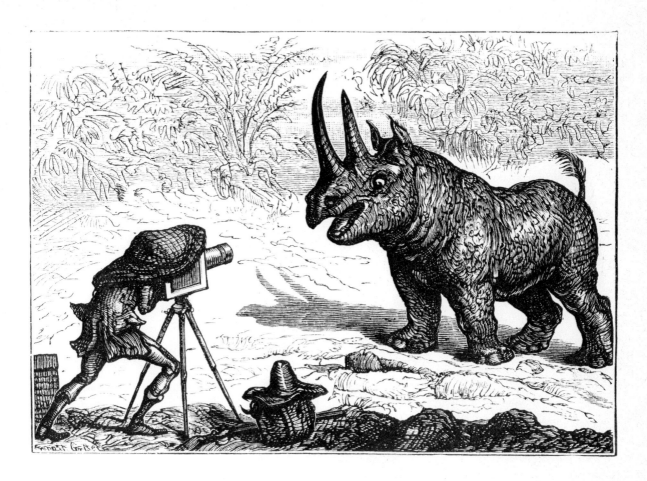

A PLEASANT EXPRESSION

'Don't be afraid! Just rest awhile,
 And don't attempt to stir,
And, if you can, look pleased and smile,'
 Said the photographer.

The young rhinoceros stood still,
 And, willing to obey,
He smiled and smiled with such good will.
 The artist ran away!

Little Folks, 1882.

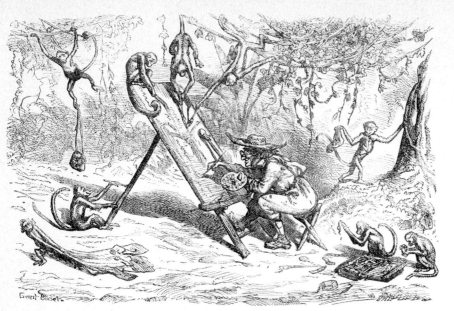

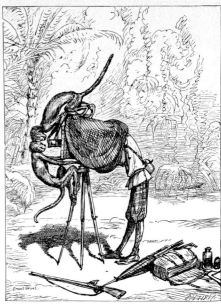

Above, left, 'Of all animals, the monkey exhibits the greatest familiarity towards man.' *Fun's Comical Creatures*, London 1884.

Above, right, two monkeys tease a hapless photographer. *Griset's Grotesques*, London 1867.

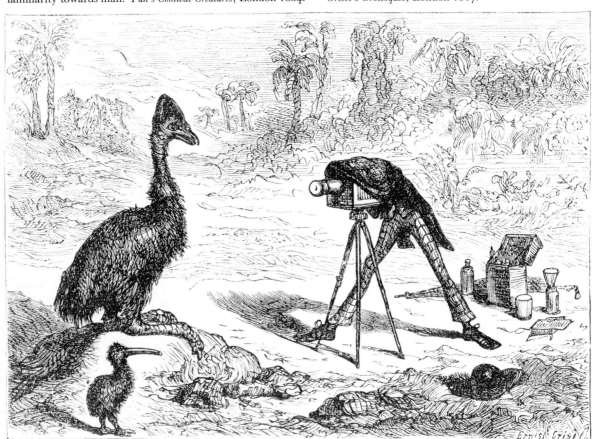

MRS. CASSOWARY'S PORTRAIT

Said Mrs. Cassowary, one sunny summer day,
'I feel that I must vary the sameness of my way!
So, ere we are forsaken by sunshine gone to rest,
I'll have my portrait taken – 'twill show me at my best!'

With ways the most contrary she sat puffed up with pride,
While a bird long-billed and wary* crept slyly to her
 side;

And after much arranging the photograph was done,
And then, with colours changing, sank slowly down the
 sun!

When madam saw the portrait, oh, great was her dismay!
She didn't quite recover for many and many a day!
So proud of every feature, she'd held too high her head,
And the little long-billed creature got photographed instead!

* The Apteryx.

Little Folks 14, 1881.

38

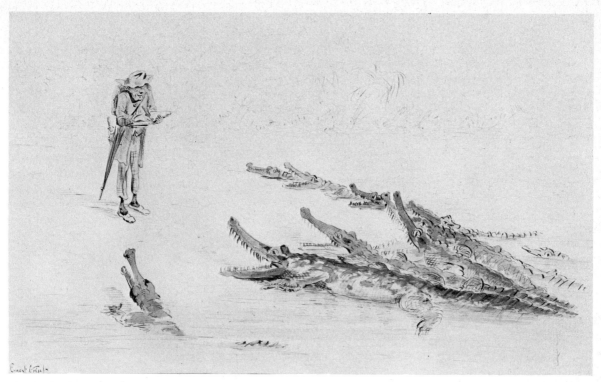

Top, A Traveller confronted by Crocodiles. Pen, ink and
watercolour. 28.2×47.2 ($11\frac{1}{8} \times 18\frac{5}{8}$).

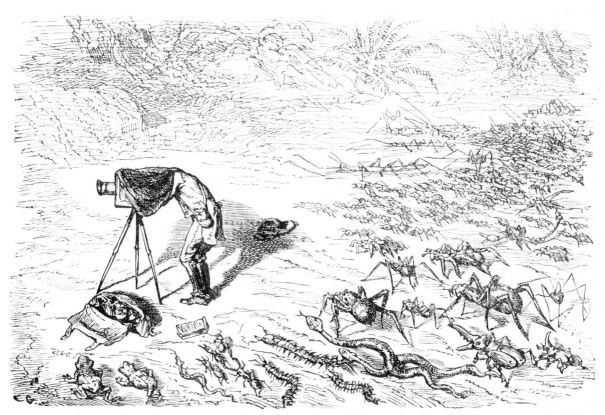

Above, 'Ah, very charming view! it only wants a few living
objects in the foreground to give it interest.' *Fun's Comical
Creatures,* London 1884.

Punch

From 1867 to 1869, Griset was employed as a staff caricaturist on the most famous of all English comic journals, *Punch*. The experience was not a happy one, for his own highly individual style and specialized interests made it difficult for him to supply the variety and number of caricatures required by the editor.

Griset portrays himself nervously greeting the editor, a portfolio of new designs under his arm. From *The History of Punch* by H. M. Spielman, London 1895.

Opening initial R to a comic article on the Royal Academy, which was published in *Punch*, 18 May 1867.

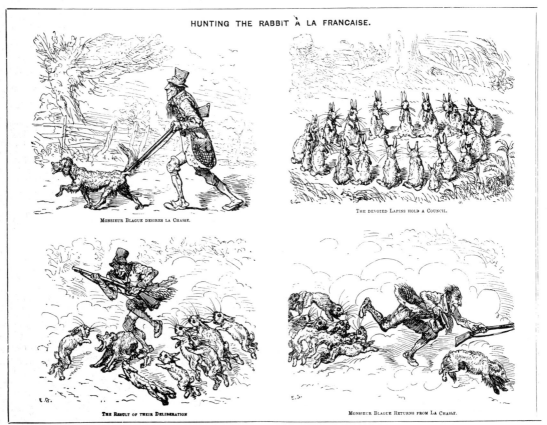

HUNTING THE RABBIT À LA FRANCAISE.

MONSIEUR BLAGUE DESIRES LA CHASSE.

THE DEVOTED LAPINS HOLD A COUNCIL.

THE RESULT OF THEIR DELIBERATION

MONSIEUR BLAGUE RETURNS FROM LA CHASSE.

Punch, 23 November 1867.

A series of drawings for *Punch*, 14 September 1867.

"HERE'S SPORT INDEED!"

MR. GRIFFIN, OF THE C.C.S., AND ENSIGN GREEN OF THE C.R.R., HAVING COME TO CEYLON IN THE SAME VESSEL, ARRANGE THAT WHEN THEY CAN GET LEAVE OF ABSENCE, THEY WILL GO TOGETHER "TO HAVE A POT AT THE ELEPHANTS." IN DUE TIME THEY GO, AND FOLLOWING THEIR TRACKER, AT LENGTH DISCOVER THE ANIMAL.

THE ANIMAL DISCOVERS THEM.

THEY ESCAPE UNSCATHED, BUT A LITTLE REFRESHMENT BECOMES NECESSARY.

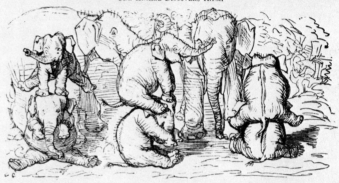

COMING IN SIGHT OF A HERD IN OPEN GROUND, THEY HAVE AN OPPORTUNITY OF OBSERVING "THE YOUNG RUNNING PLAYFULLY AMONG THE HERD, THE EMBLEMS OF INNOCENCE."—*Vide* SIR EMERSON TENNENT.

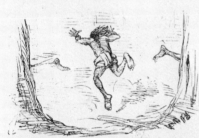

HAVING ARRIVED WITHOUT DISCOVERY IN THE MIDST OF A HERD, MR. GRIFFIN FIRES, AND TURNING ROUND TO TAKE ANOTHER GUN SEES NOTHING OF THE GUNBEARERS BUT THEIR HEELS.

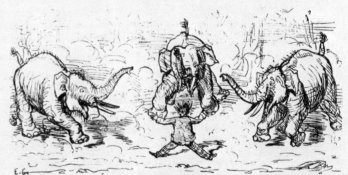

HE IS PURSUED, AND KNOWING THAT THE BEST THING UNDER SUCH CIRCUMSTANCES, IS TO TURN SHARP ROUND, DOES SO, AND FINDS HIMSELF IN THE ABOVE POSITION. *In medio tutissimus ibis (? !)*

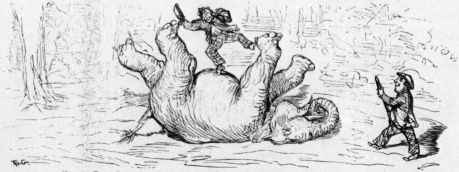

MR. GREEN TURNS UP IN THE NICK OF TIME, SHOOTS ONE, AND THE REST RUN AWAY. *Extract from* MR. GREEN'S *Diary :*—"GRIFFIN EXECUTED A PAS SEUL, WHICH FOR ORIGINALITY OF CONCEPTION, COMBINED WITH BRILLIANCY OF EXECUTION, HAS PERHAPS NEVER BEEN EQUALLED."

The Hatchet Throwers

James Greenwood, Griset's principal collaborator, had an unpleasant sense of humour, and possessed almost every mid-Victorian prejudice. In *The Hatchet Throwers*, London 1866, his first joint venture with Griset, he told the story of the Brothers Bold and their adventures in Africa. The tale, although it provided amusing anecdotes for Griset to illustrate, was condescendingly racialist in its tone.

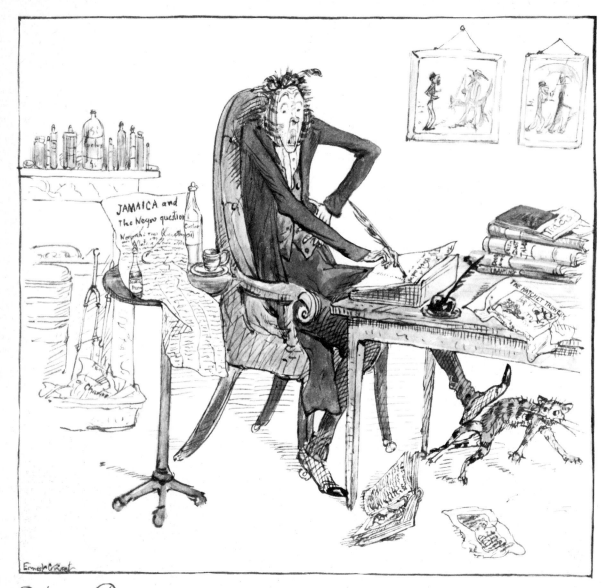

Fancy Portrait of the "dismal" writer of the annexed notice from the "Athenæum", who, labouring under an attack of colic, could not see what there is in the "Hatchet Throwers", but could see what there isn't. The writer confesses himself, however, no great wit.

Opposite, The Hatchet Throwers received very mixed reviews, directed at the author rather than at the artist, but Griset, who naturally collected all his first press cuttings, took them to heart. He retaliated with this imaginary portrait of the reviewer in *The Athenaeum*, who had been particularly vituperative. Watercolour. 22.8 × 24 (9 × 9½). By courtesy of the Victoria and Albert Museum, London.

Title page to *The Hatchet Throwers*. Griset greatly enjoyed drawing title pages and here portrays himself adding the finishing touches. He is surrounded by other characters from the book, including the author, who is pointing to his own name.

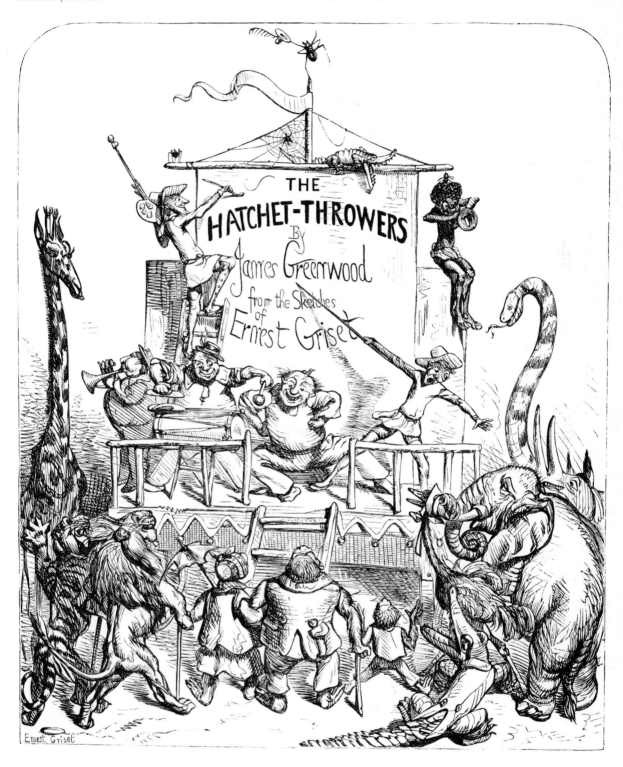

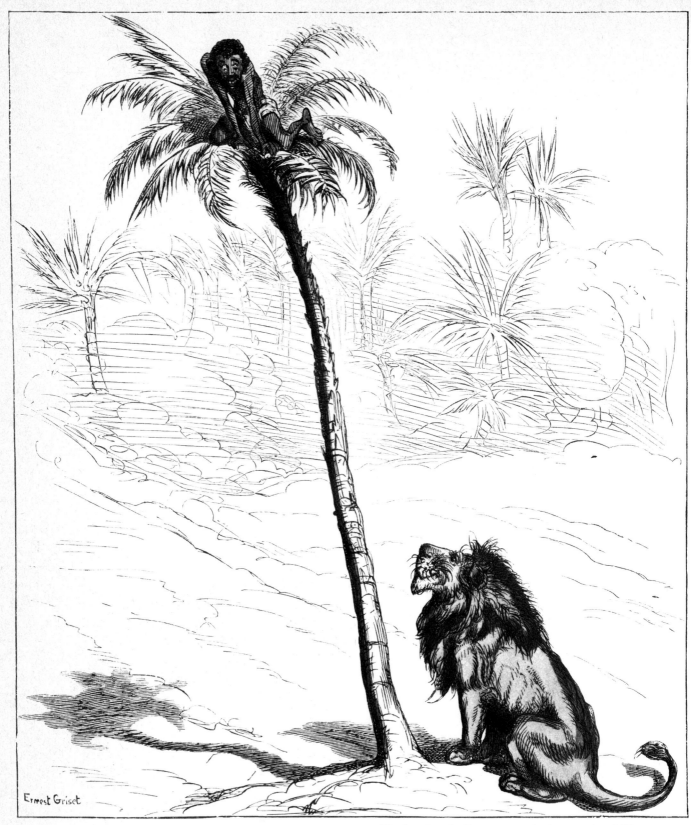

Ernest Griset

'Kaphoozlem declines to recognise her grandson.' The boy's grandmother, Kaphoozlem, has been changed into a lion and chases him up a tree.

44

'Goliah Brass, Sketching in the Great Wigglewaggle, is Unconscious of the Presence of a Critic.'

'Leg Bail'. The Brothers Brass, with the help of an ostrich, make their escape from cannibals.

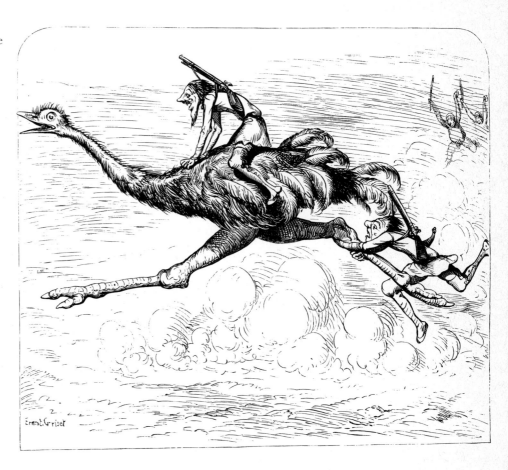

Griset's Grotesques

Griset's next collaborative venture, *Griset's Grotesques, or Jokes Drawn on Wood* with rhymes by Tom Hood, junior, London 1867, was a far happier one. The author was a prolific versifier (his father wrote the famous 'Song of the Shirt'), and some of the jingles are included here. For this publication, Griset happily adopted a bold, simple style which was ideally suited for translation into woodcuts. The blocks were made by the Dalziel Brothers, in their early style (later they adopted the harshly contrasted chiaroscuro technique which so suited the drawings of Gustave Doré).

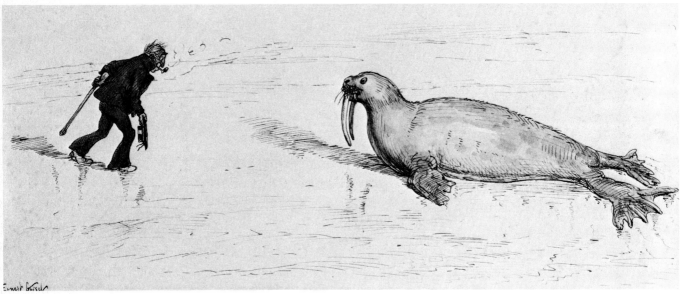

Above, Man and walrus. Pen, ink and watercolour. 48 × 19.5 (7⅞ × 18¾). Author's collection.

Below, Sailors astride a walrus. Pen, ink and watercolour. 25.7 × 48.2 (10⅛ × 19). By courtesy of the Victoria and Albert Museum, London.

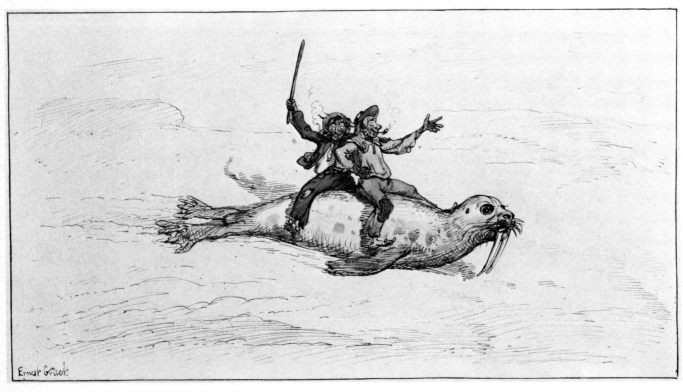

46

THE FROZEN PHANTOMS

There were two jolly sailors
 Set sail upon a seal;
On one intent they both were bent, –
 The North Pole to reveal!

They steered away to nor'ard
 Across the ice and snow;

On deck they kept, and never slept,
 (They couldn't go below!)

But soon the arctic frost did
 Their flesh and blood congeal,
And stiff as mummies and dead as dummies
 They still ride on that seal.

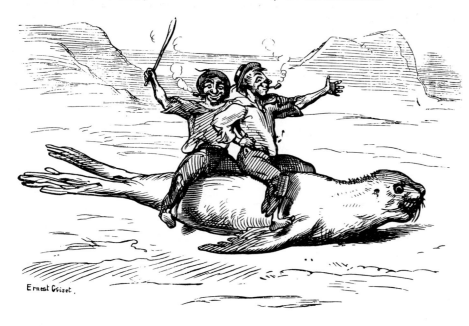

Ernest Griset.

Griset must have been familiar with Lecomte's sea-lion act at the Zoo, which may have inspired these drawings. Lecomte's sea-lion died early in 1867, but the public was diverted by the arrival of a similar novelty, the walrus. Griset used this striking animal in his first sketches to illustrate 'The Frozen Phantoms', but, for the published plate, he reverted to a picture of a seal (perhaps his collaborator, Hood, found it difficult to find words to rhyme with 'walrus').

Sailor tempting a seal with a crab. Pen, ink and watercolour. 26.5 × 52.1 (10½ × 20½). By courtesy of the Victoria and Albert Museum, London.

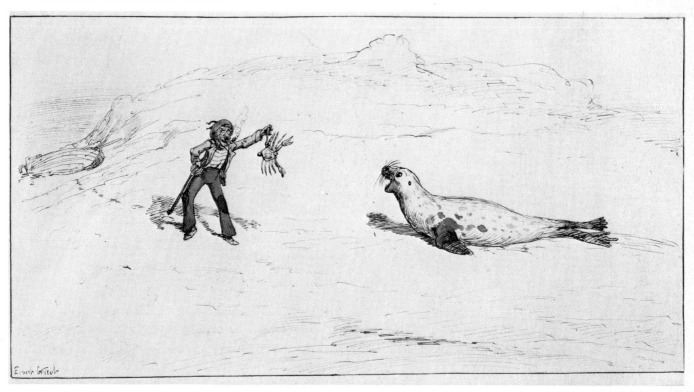

THE HOG FAMILY.

An Operetta for the Drawing-room.

[N.B.—All the effects in this piece are registered, and the music entered at Stationers' Hall.]

𝔇𝔯𝔞𝔪𝔞𝔱𝔦𝔰 𝔓𝔢𝔯𝔰𝔬𝔫𝔞𝔢.

Mr. Big Boar	Master Pig
Mrs. Sow	Master Piggywig

Piggywigling.

Scene I. AN OPEN GLADE.

Enter Mr. Big Boar.

Mr. B. B. Grumph, grumph, grumph, grumph!

[*Soft music.*

Enter Mrs. Sow.

Mrs. S. Umphy, umphy, umphy, umphy!

Mr. B. B. Grumph!

Mrs. S. Umphy!

DUET.

Mrs. S. Umphy, umphy, umph.

Mr. B. Grumph, grumph, grumph.

Both⎰ Umph, grumph, gr-r-r-umph!

[*Alarums and excursions.*

Enter Master Pig.

Master Pig. Oooink, ooink!

[*They start.*

Enter Master Piggywig.

Master Piggywig *(aside)*. Oonk, oonk, oonk!

116

QUARTETTE.

Mr. B. B. Grumph!

Mrs. S. Umph!

Master Pig. Ooink

Master Piggywig. Oonk, oonk, oonk!

> [*They perceive an acorn, rush towards it,*
> *and sing the chorus.*

All. Gruooinkurmph-urmph-urmph!

> [*They regale themselves on the acorn,*
> *when enter suddenly* Piggywigling.

Piggywigling. Week, weeeek, weeeeek!

> [*They gather round him with gestures*
> *expressive of sympathy and affection.*

Piggywigling (*imploringly*). Oonweeeek, oooeweeeek!

> [*A shot is heard in the distance.*

Mr. B. B. Grrrrruuuumph!!

> [*Exeunt rapidly in procession.*

Curtain.

117

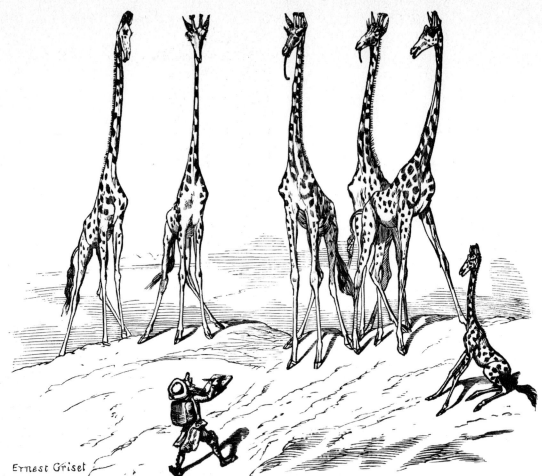

HIGH ART

'Sky-scraper,
 Oh, law!
Long paper
 If I draw!'

Progress slow,
 By degrees!
'Tishoo!' Oh
 What a sneeze!
On the sly,
 Paper peppered.
Good bye,
 Camelopard!

Ernest Griset

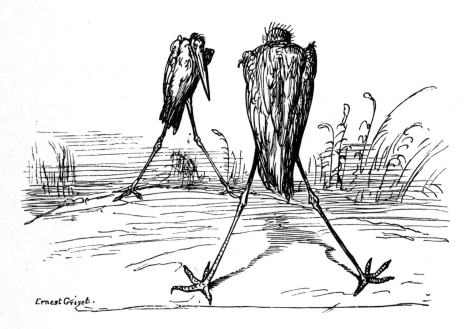

Ernest Griset.

CAUSE AND EFFECT

These are two Virginian storks,
With legs as long as toasting-forks.
Why they're standing in this way
Is rather more than I can say.

COCK-A-DOODLE-DO-O-O

They caught him by a *ruse*,
They gave his necks three screws,
 And so they brought
 At once to naught
His 'Cock-a-doodle-do-o-os!'

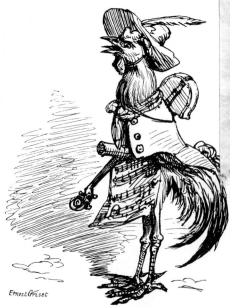

Ernest Griset

50

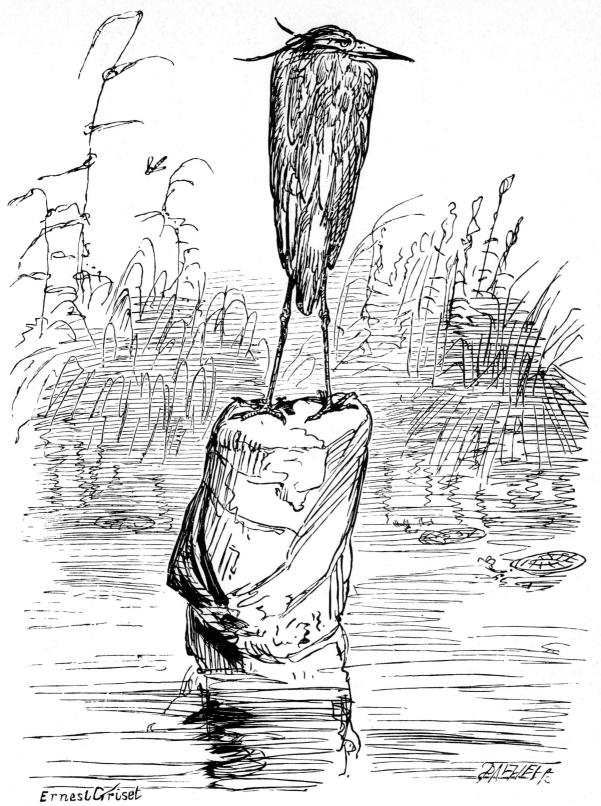

Ernest Griset

THE HERON IN LOVE

The love-sick heron went back to his rock:
His feelings had met with a dreadful shock,
 To think she made pegs
 At his graceful legs,
And could at his noble demeanour mock.

The Purgatory of Peter the Cruel

In illustrating James Greenwood's unpleasant tale, *The Purgatory of Peter the Cruel*, London 1868, Griset produced what could be considered to be his masterpiece. Greenwood tells the story of Peter, an extremely cruel little boy, who is punished for his sadism by being transformed into the creatures he so enjoys tormenting. The story must surely have been prepared with Griset's co-operation, for it abounds with opportunities to depict his favourite subject:

insect life. Much of the power of these fantasies stems from their basis in fact.

The book was published with black and white plates, but in some volumes the plates have been hand-coloured. The painting is of such high quality that it must have been done, if not by the artist himself, then under his direct supervision. The reticent, delicate use of watercolour and gum arabic gives the plates a rare distinction.

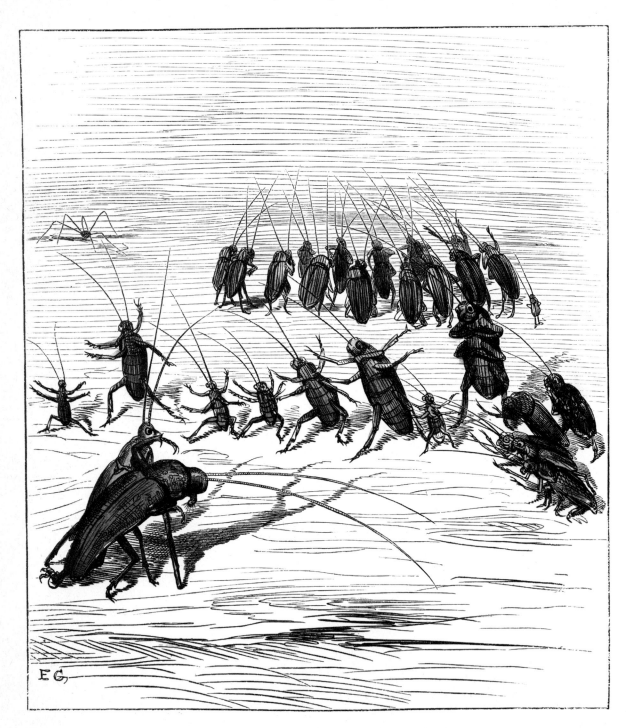

Below, 'Peter the snail gets acquainted with a jolly young blackbird.'

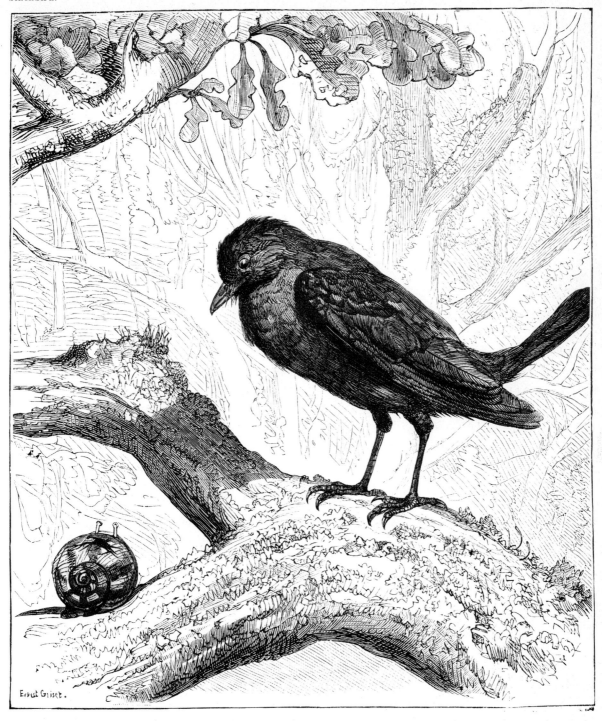

Opposite, a crippled cockroach, maimed by Peter, returns to the bosom of his family.

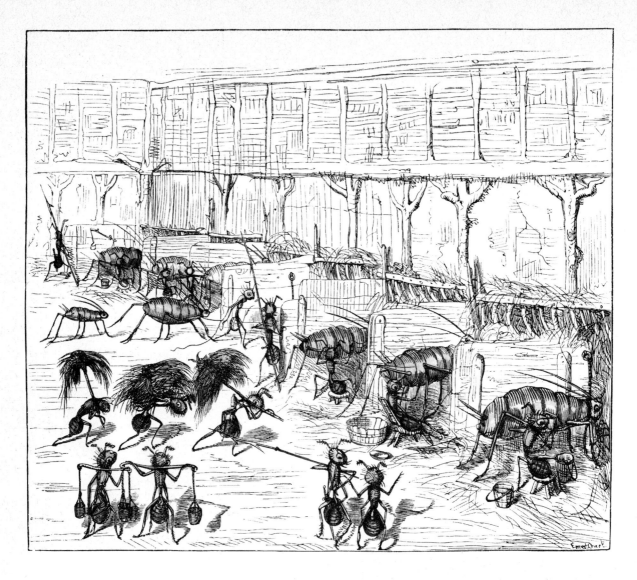

Peter the ant is given the task of milking the aphis cows. This seemingly fantastic incident is in fact based on the actual life of the ant. The ant tickles the greenfly with its antennae and then milks the aphid's tubes dry of honey-dew. This 'milking' of the greenfly is the main duty of the worker ant outside the nest.

Peter emerging from the last of his purgatorial disguises. This drawing epitomizes Griset's central concern: the wish to 'get under the skin' of his animal subjects.

Aesop's Fables

This book, which was published in London in 1869 and which would seem to be such an ideal vehicle for Griset's talents, did not, in fact, produce his most individual work. Gustave Doré's *Fables de La Fontaine* had come out in 1867, and the influence of the great French illustrator was at its height. Griset is clearly imitating Doré's style although, of course, his publishers may have instructed him to do so, in an attempt to profit by the French artist's success without having to pay his fees.

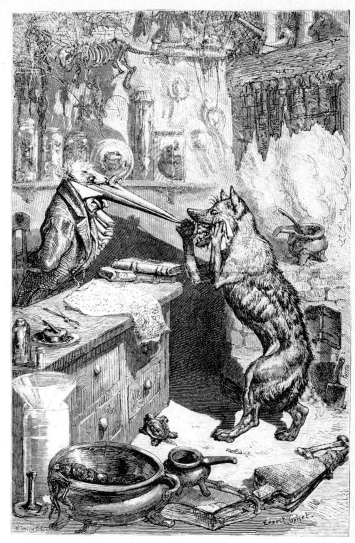

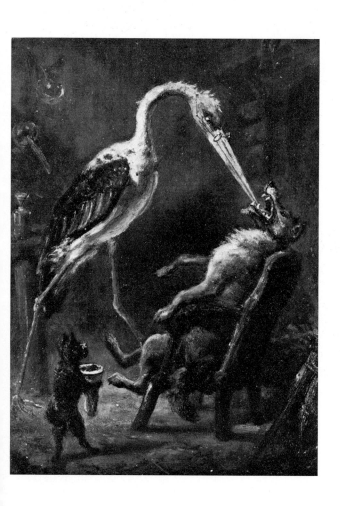

The Wolf and the Crane. The wolf had a bone stuck in his throat and promised the crane a reward if he removed it. The crane extracted the bone, then asked for the reward. But the wolf replied, 'Why, you have had your head in a wolf's mouth and escaped with your life. What could be a greater reward?' Griset did two versions of this fable: one was this wood-engraving, the other was one of his rare oil paintings.

The Wolf and the Crane. Oil on board. 29.8 × 21.6 ($11\frac{3}{4} \times 8\frac{1}{2}$). By courtesy of the University of Glasgow.

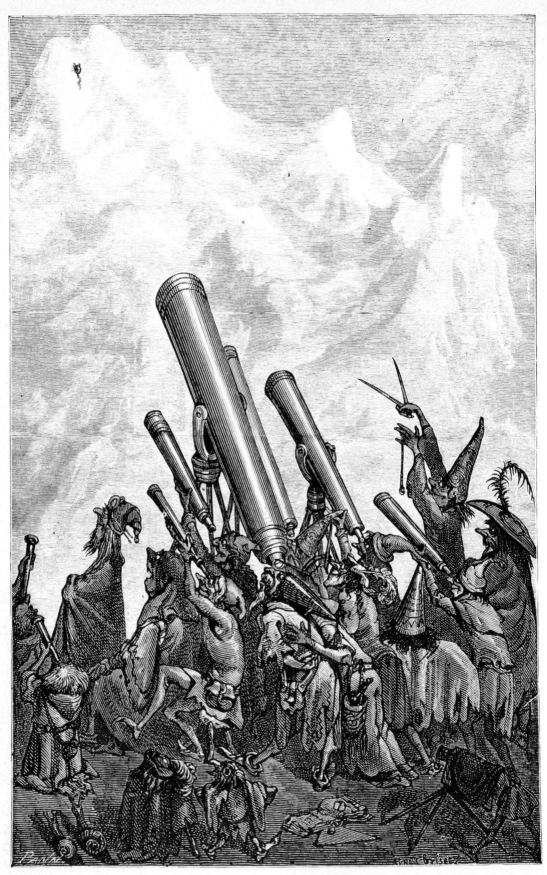

The Mountain in Labour. It was said that a mountain, from which were issuing dreadful groans, was in labour and people flocked to see what would be produced. They waited and waited, until eventually out crept a mouse.

56

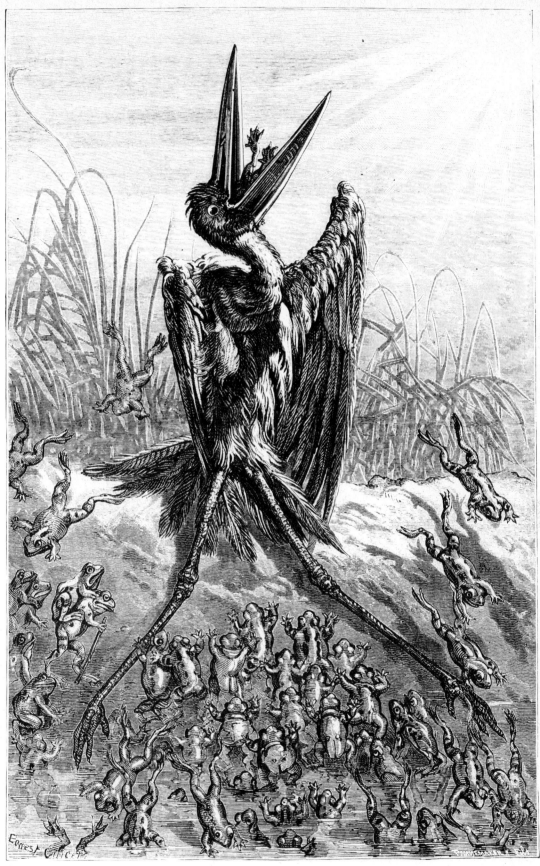

The Frogs Desiring a King. The frogs begged Jupiter to send them a king. He sent them a log of wood, which they found boring. He then sent them a stork, who gobbled them up. The moral is: be content with your lot.

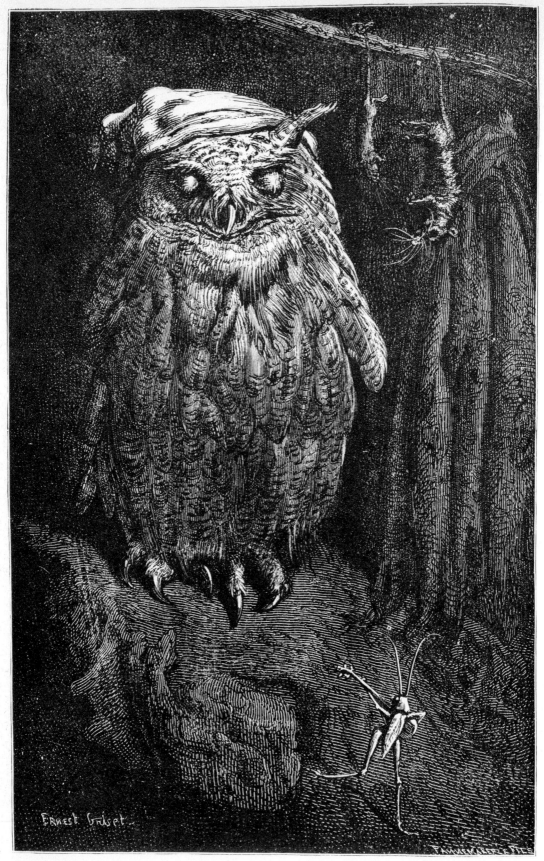

The Owl and the Grasshopper. The owl was disturbed by the grasshopper's singing and could not sleep. So he flattered the insect by telling him what a beautiful voice he had, and asked him to come nearer, so that he could hear better. When the unsuspecting grasshopper came within reach, the owl killed him and finished his nap in peace.

Quirks and Quiddities

A pot-pourri of Griset's fantasy taken from various stages in his career.

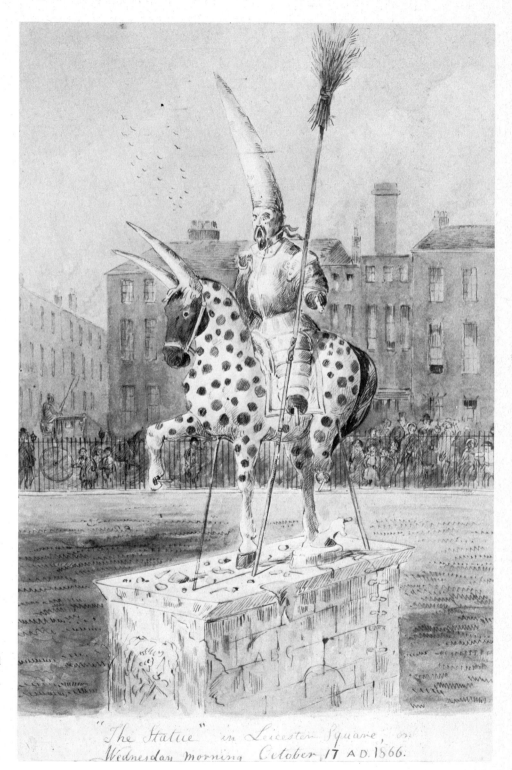

"The Statue" in Leicester Square, on Wednesday morning October 17 A.D. 1866.

This is one of Griset's earliest surviving watercolours. It depicts a strange incident that he witnessed on the morning of 17 October 1866, on his way to his bookshop in Leicester Square. The Statue of George I, which had fallen into disrepair, had been transformed by vandals overnight by the addition of a dunce's cap, a broom and the liberal application of coats of paint. Pen, ink and watercolour. 46.3 × 31 (8¼ × 12¼). By courtesy of the Victoria and Albert Museum, London.

'Certainly, I *am* handsome', said the duck, looking into the water.

'*Very*', said the fox, carrying her off for his dinner.

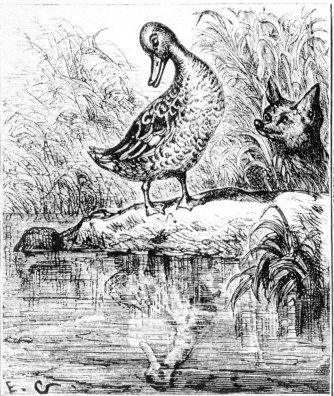 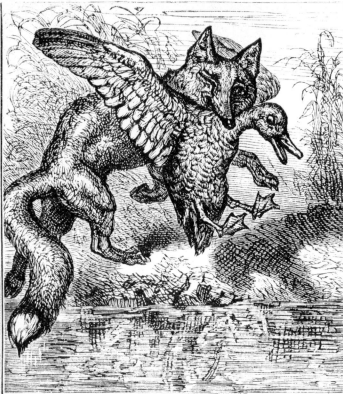

A harsher and more realistic treatment of this theme than that adopted by Beatrix Potter in *The Tale of Jemima Puddleduck*. *Little Folks 14*, 1881.

DIGNITY AND IMPUDENCE.

A FABLE.

SAID a wee little bird, with
 a pert little look,
To an adjutant stork by
 the river—
" I suppose that you think
 you're as wise as a
 book,
 And in fact that you're wondrously
 clever !
You're a picture of dignity, that I'll
 admit,
 But alas ! that is all I'll allow,
For indeed you're not quarter as wise as a tit,
 That hops to and fro on a bough."

Said the adjutant stork to the wee little bird,
 With a dignified kind of a stare—
" Little creatures like you should be seen and not
 heard,

And your impudence well we can spare !
You had better by far go back to your nest,
 And be pert where they'll heed what you do ;
For you see that in height I'm six feet and the
 rest,
 While you are just no feet two ! "

So it is with us all as we pass through the
 day :
 For we each of us think we're most clever—
Whether impudent bird that chatters away,
 Or " Dignity " stork by the river.
On our size or our form or our talents we
 pose,
 And we hold ourselves up ev'ry hour :
If the Queen of the Garden be known as the
 Rose,
 Then we are that wonderful flower !
 G. WEATHERLY.

Dignity and Impudence. The title of Landseer's famous painting is often used for the sentimental comparison of two different characters. Here, it is applied to a heron and a pied wagtail. *Little Folks 14*, 1881.

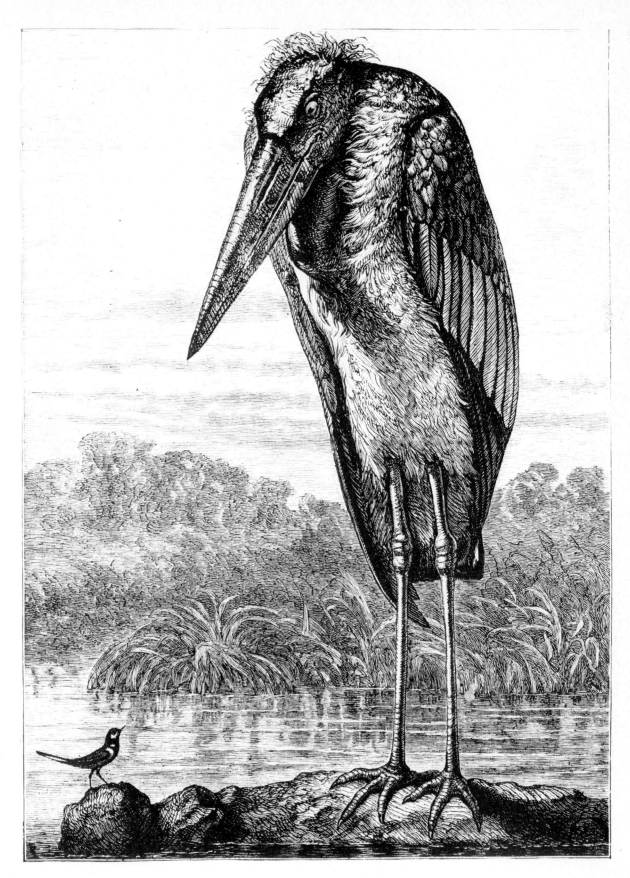

The Tact of the Turtle.
A fine illustration accompanying a meaningless jingle from *Fun's Comical Creatures*, London 1884.

A duck and a stork, from a series of watercolours of animals and birds in human situations. These birds seem to be enjoying a night at the opera. 19.15 (7¾) square. From the collection of John Lewis.

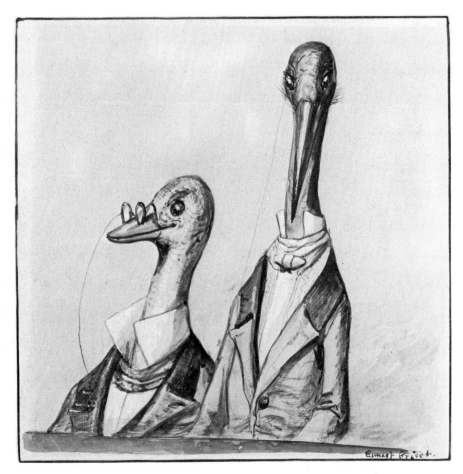

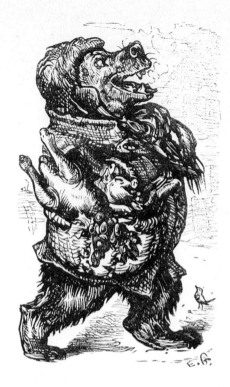

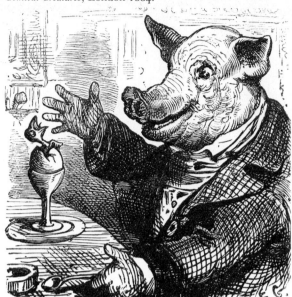

Below, left and right, A hungry pig, after returning home laden with stolen provisions, sits down to enjoy a boiled egg, but is dismayed to find that it has an occupant. *Fun's Comical Creatures*, London 1884.

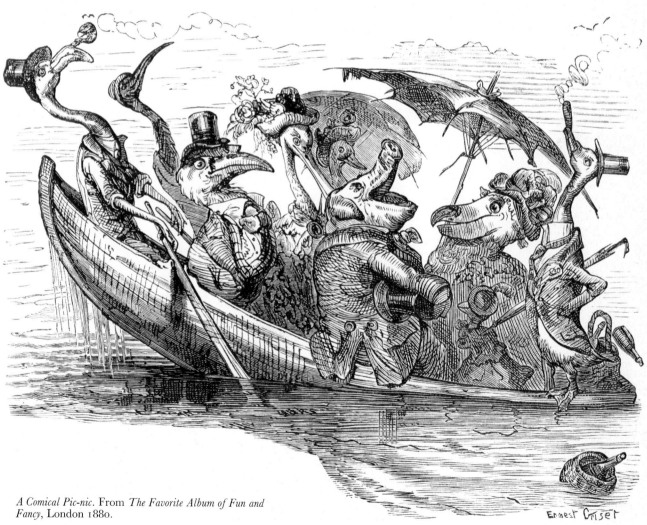

A Comical Pic-nic. From *The Favorite Album of Fun and Fancy*, London 1880.

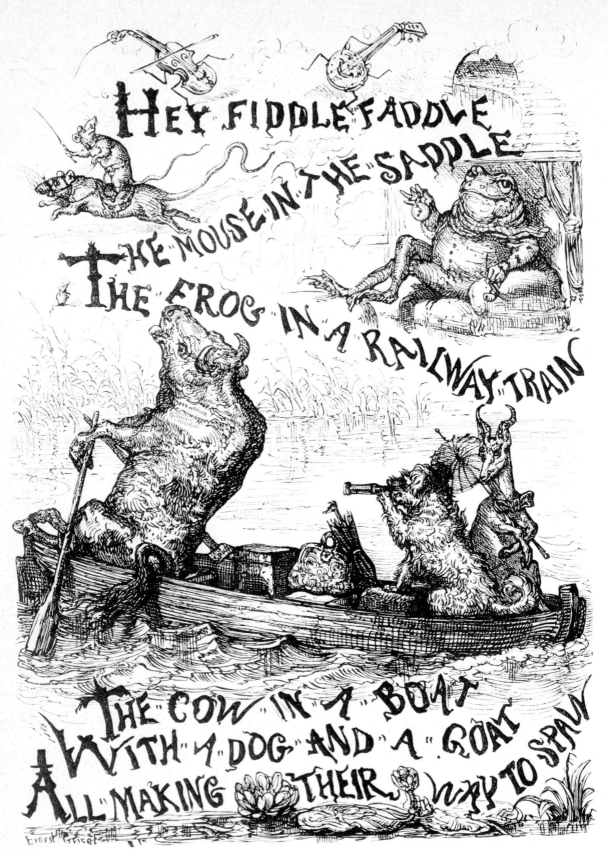

Hey Fiddle Faddle. A variation on the ever-popular nursery
rhyme, 'Hey diddle diddle'. *Little Folks*, 1882.

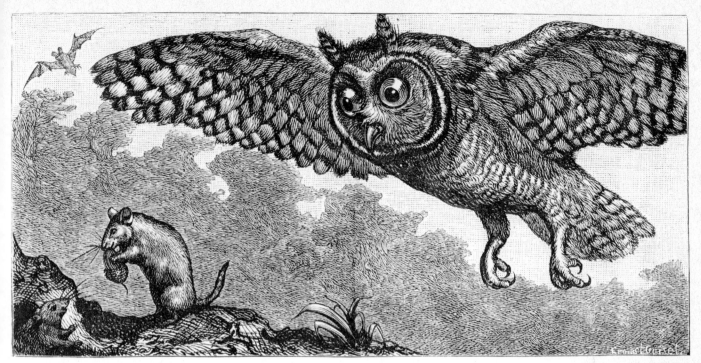

Little Dosey-mosey the Dormouse. The little dormouse is seized by a long-eared owl and borne off as food for her children. But the owl, shot by a gamekeeper, drops the dormouse, who finds himself lost and far from home. *The Favorite Album of Fun and Fancy*, London 1880.

'Father Cricket was dying.' From the story of 'Tina, the Wilful Cricket' in *The Favorite Album of Fun and Fancy*, London 1880.

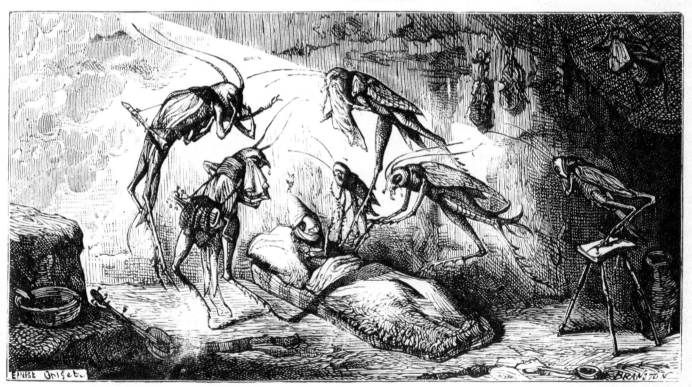

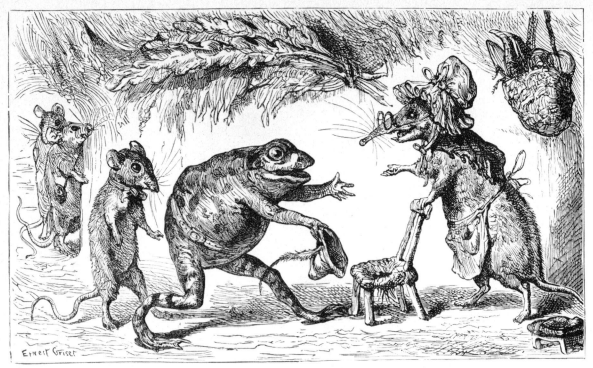

'The frog presented his companions to her.' From the story, 'When the Cat's away the Mice will Play', in *The Favorite Album of Fun and Fancy*, London 1880.

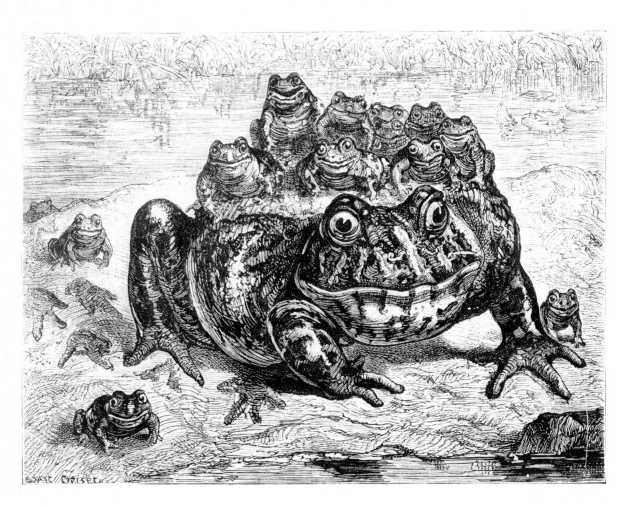

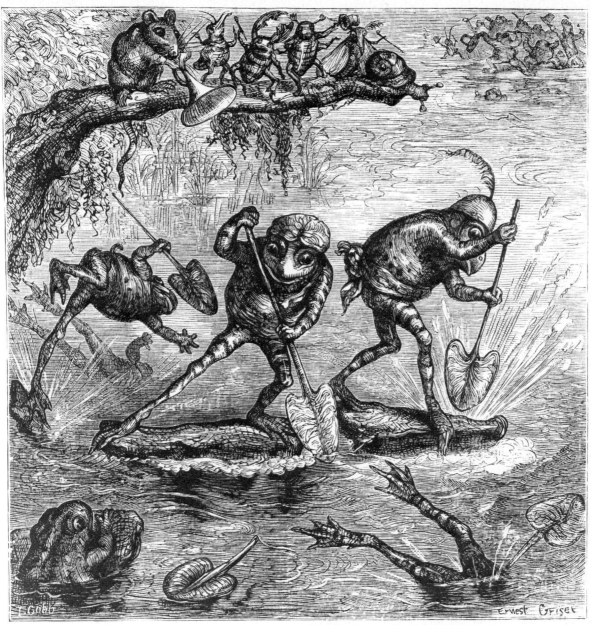

Frogs competing in a sculling match. The frenzied crowd on the bank is perhaps reminiscent of the annual University Boat Race, an event very popular in Griset's day. *Little Folks 14*, 1881.

Opposite,

A COMICAL FAMILY

'Yes, here I come with a wondrous pack
Of little ones upon my back.'

This drawing, for all its wild improbability, is factually correct. The Borneo tree-toad does indeed carry its young on its back in this way. *Little Folks*, 1882.

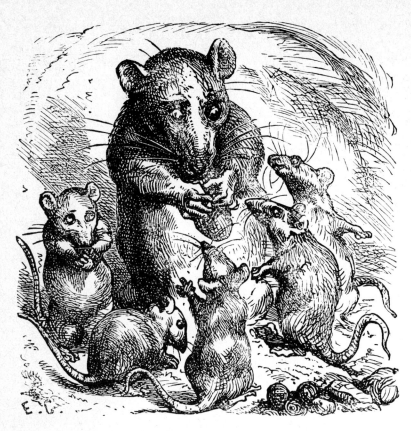

Left, *Tale of a Mouse*. A wood-engraving taken from the watercolour, *Dinnertime*. It is sad to see how the wood-engraving process could, in unskilled hands, reduce an artist's work to a travesty of the original. Reproduced in *Fun's Comical Creatures*, London 1884.

Below, *Dinnertime*. The original design for *Fun*. Pen, ink and watercolour. 14.6×23.5 ($5\frac{3}{4} \times 9\frac{1}{4}$). By courtesy of the Victoria and Albert Museum, London.

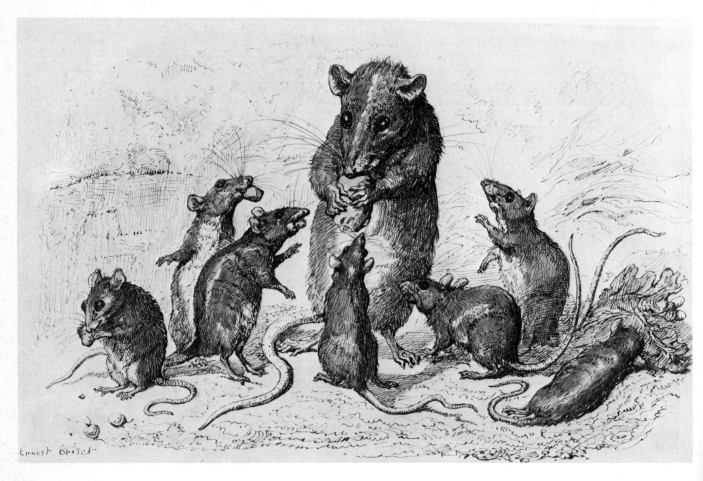

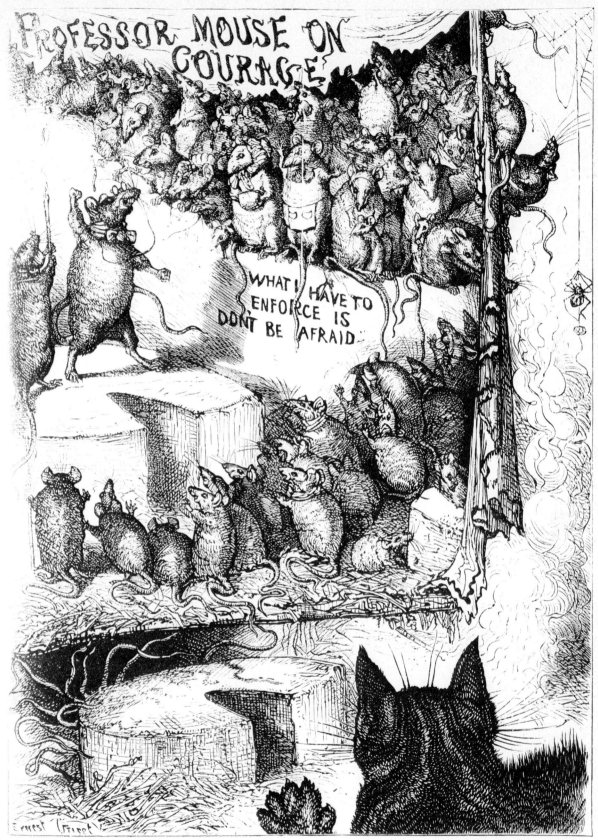

Professor Mouse on Courage. The valiant professor stirs his
fellow mice to resist the evil cat. They all agree – until
the cat himself joins the meeting, whereupon they all flee,
the professor in the lead. The theme of courage and mice
has preoccupied writers from Aesop to Margery Sharp.
Little Folks, 1882.

The Wolf and the Boar. The rapacious wolf is told by a fox that he will find a succulent pig in a nearby den. But, instead, a fierce wild boar rushes out, and the wolf flees in dismay. *Little Folks 14*, 1881.

SPRING.

SUMMER.

The Seasons. Griset's interpretation of this popular theme is characteristically anthropomorphic and owes much to Grandville – notably the drawing of *Autumn*, which shows a fish fishing (an idea perhaps taken from Grandville's book, *Un Autre Monde*). *Fun's Comical Creatures*, London 1884.

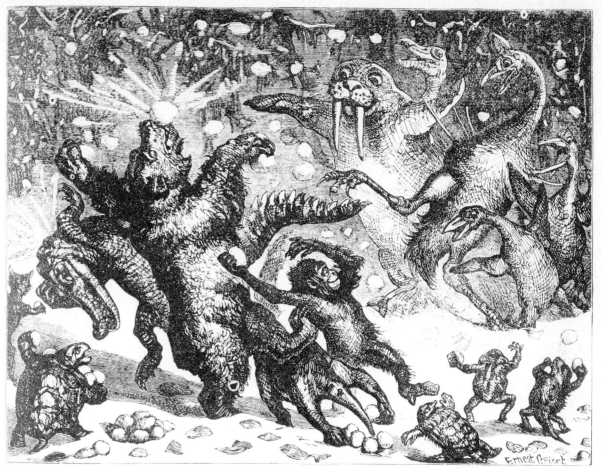

The Bear's Snowball Match. Children's comics invariably treat the theme of snowballing in exhaustive detail from November to March. Victorian comics were no exception. *Little Folks*, 1882.

AUTUMN.

WINTER.

Then rush together might and main,
And soon the tall cliffs ring again
With all the noises of the strife,
For each one strives as if for life.
At first it seems as if the fight—
So equal was each rival's might—

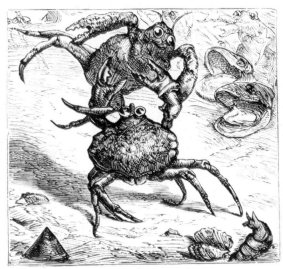

TWO sturdy crabs, well known to fame,
 Cancer and Decapod by name—
In every sport stern rivals they—
Determine one bright summer day
Upon the beach their skill to try,
And in a wrestling contest vie.
No time is lost ; and soon the ground
Is marked out for the fray ; around

Would never end ; yet still each crab
Tries hard to gain the winning grab.
Until at length strong Cancer twists
Old Decapod with mighty wrists,
And with a shout and ringing smack,
Throws him clean over on his back.

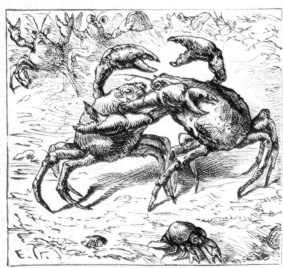

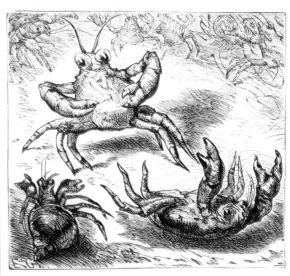

An eager host, with straining eye,
Watch for the coming rivalry.
The strife begins. With careful touch,
Each anxious for the firmest clutch,
Claw clasped in claw one moment stands ;
Then amid cries from friendly bands,
Of " Cancer !" " Decapod !" " Now, now !"
They gaze with more determined brow,

The strife is o'er, and everywhere
Loud cries of triumph fill the air ;
While Cancer, with a ruddy face,
Stalks proudly smiling round the place.

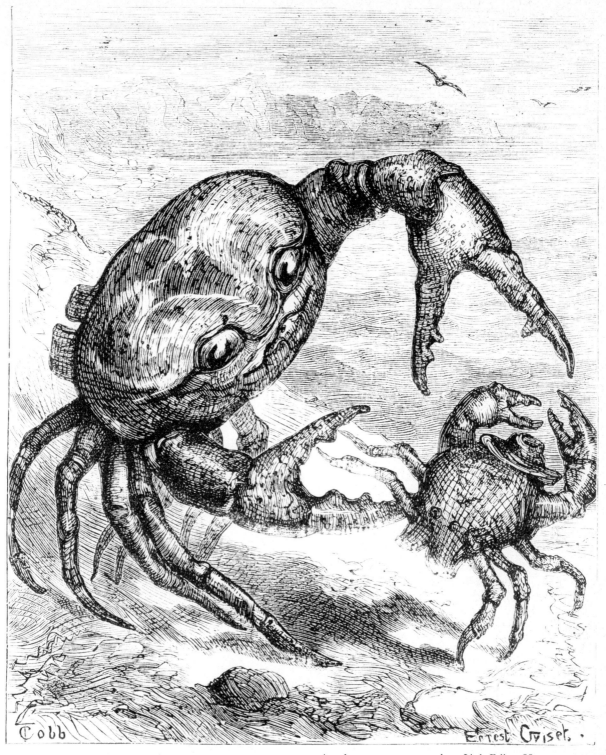

Another crustaceous combat. *Little Folks*, 1882.

Opposite, One wonders whether the wrestling term 'Boston
Crab' originated from such a contest! *The Favorite Album
of Fun and Fancy*, London 1880.

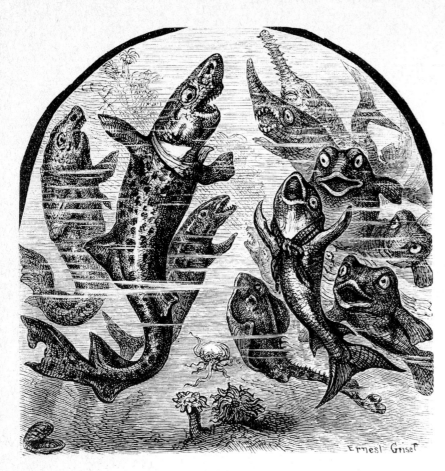

The denizens of the deep enact a war-dance in preparation for their attack on some divers. *Little Folks*, 1882.

Mrs Grasshopper's Tennis Party. Mrs Grasshopper decided to give a tennis party and invited the earwigs, ladybirds, wasps, cockchafers, dragon-flies and bees. Here, they start to play, using bats made out of daisy leaves and balls made from seeds of goose grass. *Little Folks 14*, 1884.

THE CRAB

'Accept,' he said (polite above his station),
'This European Crumb from this Crust-Asian!'
Fun's Comical Creatures, London 1884.

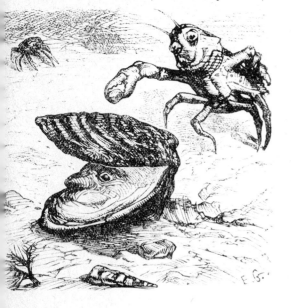

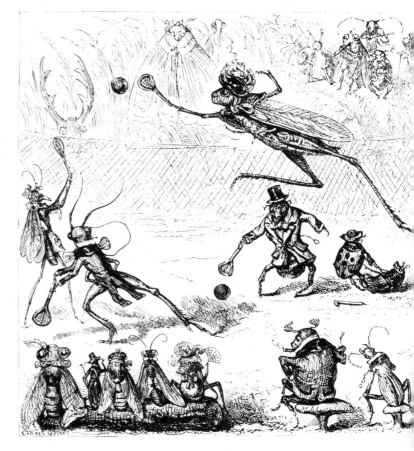

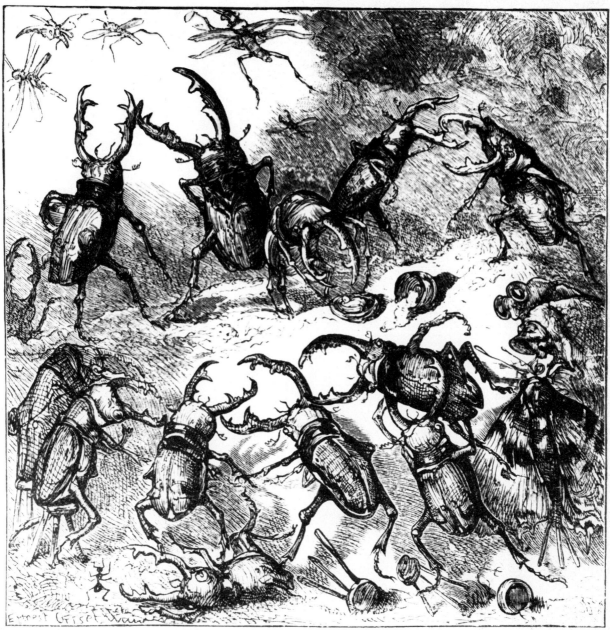

The Beetles' Banquet. This drawing is of particular interest, since the scene is depicted almost completely naturalistically, with only the introduction of some overturned bowls and stools to humanize the incident. The accompanying description of the scene was almost certainly written by Griset himself: 'It must not be supposed that sumptuous dinners are confined to the human species alone. Rich feasts are often enjoyed by animals much lower in the scale of creation, as the following account of a naturalist's experiences will show. He was lying in his garden one warm afternoon in summer, under the shade of an old oak-tree, when a peculiar rustling noise struck his ear. . . . The naturalist obtained a ladder to examine into the matter more closely. He found that sap was exuding from the bark, and that before this dainty dish there had sat themselves down a promiscuous gathering of insects. Large ants were there, and groups of flies and angry hornets; but most conspicuous among the self-invited guests were the stag-beetles. . . . Females, sad to say, fought with females in the fierce contest for the food, but the combats of the males were particularly keen; their antler-like horns interlocked, each pair struggled madly together until one or other dropped to the ground exhausted, leaving the victors to lick up the sap like greedy gluttons.'

Little Folks 14, 1881.

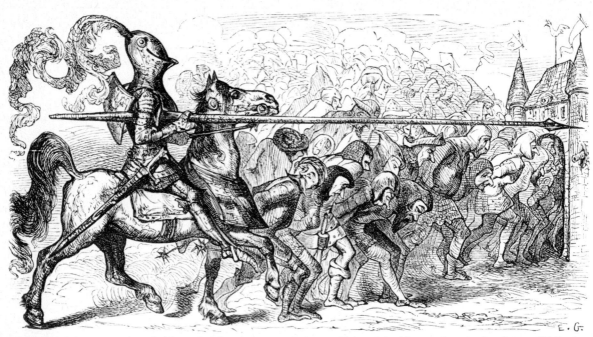

SIR GUIDALANCE was a brave knight, and of gigantic power; numbers could not subdue him, treachery *might*. In one of his battles he single-handed took a great company of prisoners, and drove them to his stronghold at Humbledown Tower.

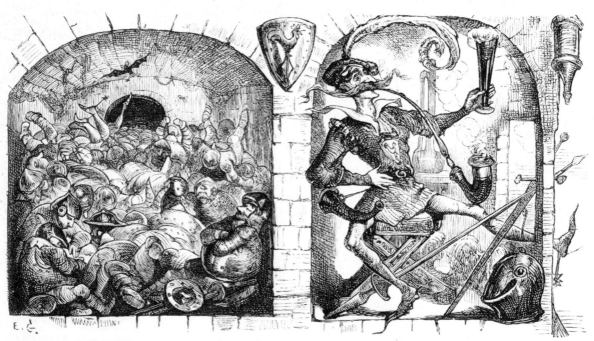

This is the dungeon, five thousand feet below the surface, where he confined the living testimony of his mighty prowess.

This is how the doughty SIR GUIDALANCE enjoyed himself in his paternal stronghold at Humbledown after the battle.

Griset did a number of drawings on mock-medieval themes, which Dicky Doyle's *Comic Histories* had made very popular. *Hood's Comic Annual*, London 1879.

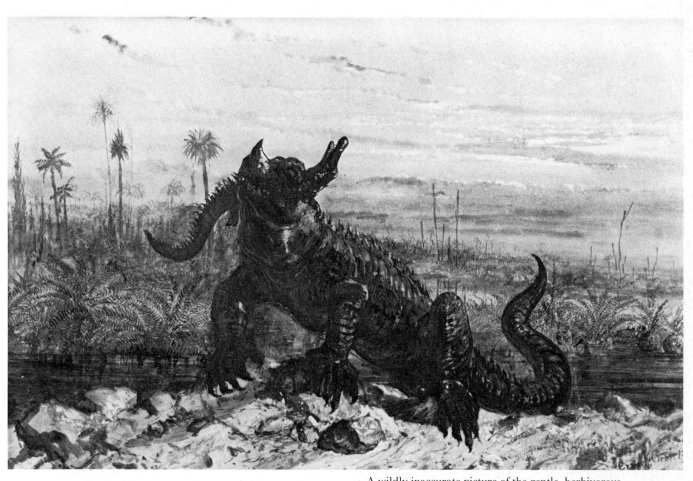

A wildly inaccurate picture of the gentle, herbivorous
brontosaurus fighting a crocodile. Gouache. (Size and
owner unknown.)

Our London

The immense diversity of Victorian London was recorded by Henry Mayhew in his *London Labour and the London Poor*, 1851–61, and also by Blanchard Jerrold and Gustave Doré in *London, a Pilgrimage*, 1872. In *Our London*, from *Fun's Comical Creatures*, London 1884, Griset takes the same themes as his distinguished predecessors, but, as always, turns them into their anthropomorphic equivalents. His *Coffee Stall* bears an uncanny resemblance to Mayhew's (engraved from a daguerreotype), except that men are replaced by birds. *The Lord Mayor's Show* is recorded with the same panache as that which Doré brought to his depiction of the Boat Race and of Derby Day, but again human figures are replaced by animals and the procession and banquet turn into a fantastic parade of lobsters, crabs and turtles.

Opposite, Saturday Night. One of Griset's most haunting series of pictures, a vivid realization of the streets of London crowded with stalls selling hot potatoes and oysters, with cheap-jack salesmen selling gold watches, with drunks and housewives – all transformed into animals and birds.

SALOOP

This nice-looking group is enjoying its soup, –
The kind that they used to describe as 'saloop';

THE OYSTER STALL

'Here you are! the finest natives! best of appetite-creatives, Come and buy! Taste and try!'

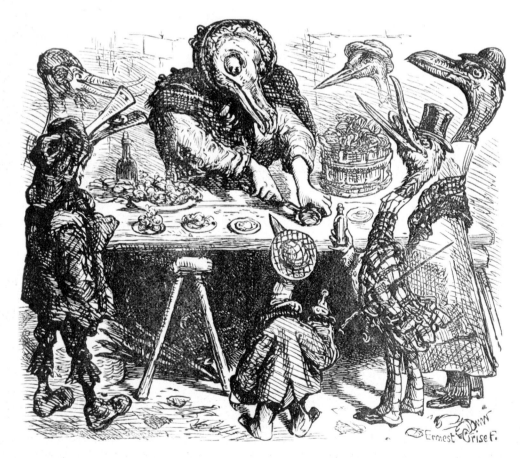

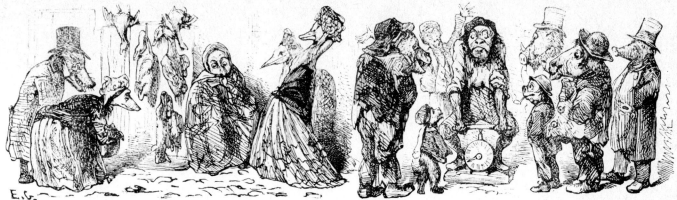

Saturday Night! Markets invite. 'Buy! Buy! Buy! Buy!' 'Come, your strength try!' That is the cry, On Saturday Night!

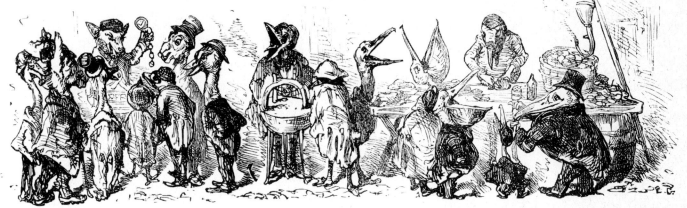

Saturday Night. Rogues their dupes bite! 'Gold watch for sale!' Oysters, all hail! Let us regale On Saturday Night.

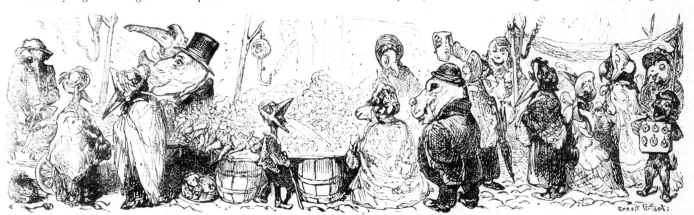

Saturday Night. Shopping at height. Trotters, fried fish. Greens if you wish. Pudding per dish. On Saturday Night!

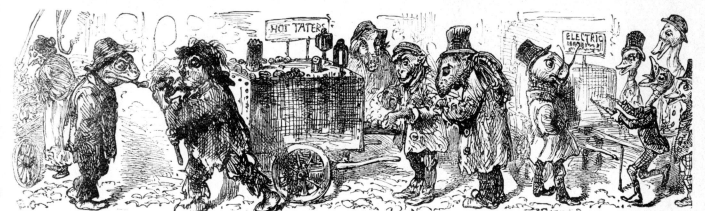

Saturday Night. Some getting tight. Others delight In taters, hot quite! Strange is the sight On Saturday Night!

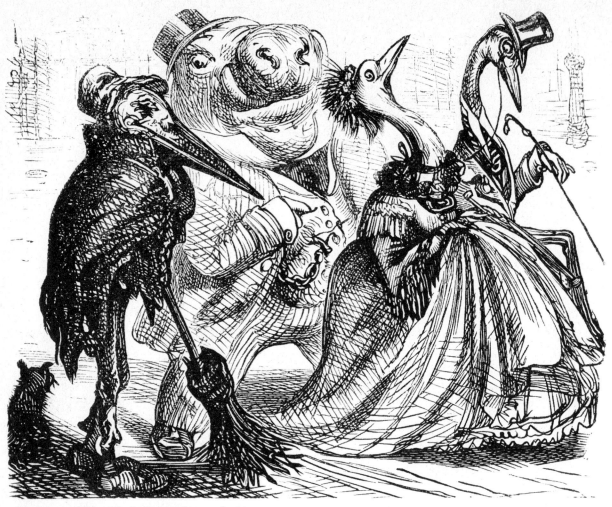

The Sorrows of Samuel Stork, Crossing Sweeper. In this caricature, we again find a mingling of the Zoo and Mayhew's *London Labour and the London Poor*. The latter contains many interviews with crossing sweepers, who fulfilled so vital a function in the days of horse-drawn transport.

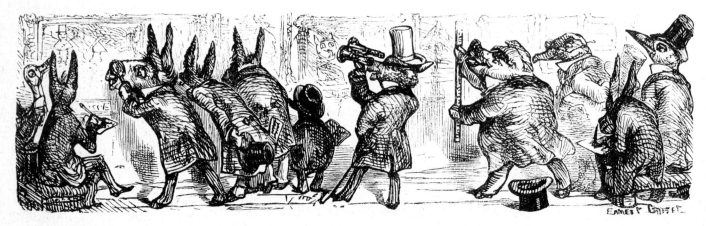

AT THE ACADEMY – PORTRAITS OF EMINENT CRITICS

'Only a moment to stop. Ten columns of criticism to do today!' The critics are, inevitably, portrayed as asses and pigs.

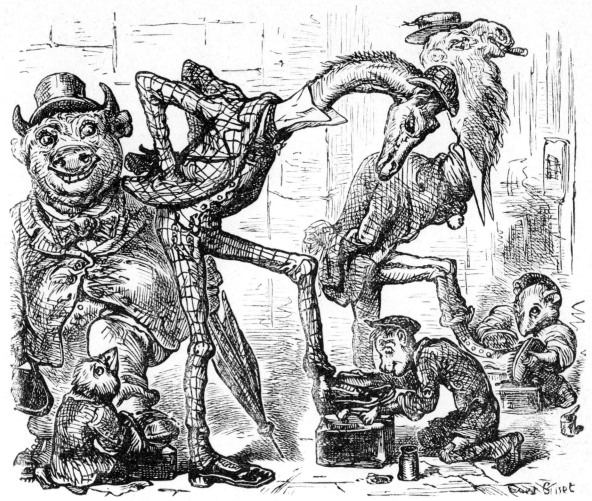

SHINE YOUR BOOTS, SIR?

Shine 'em up, sir? Very muddy,
If appearances you study.

Shine 'em up, sir? In a minute
See your face reflected in it!

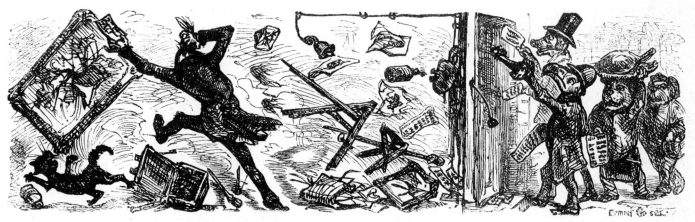

NOT AT THE ACADEMY – DECLINED AND FALLEN

'Hang the hangers I say!'

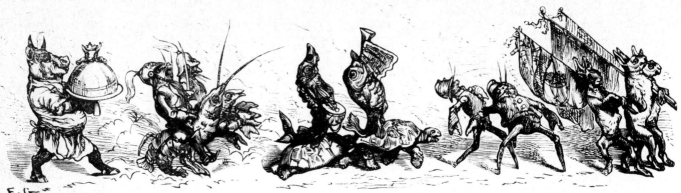

THE hares upon the air fling forth the banners,
The unboiled-lobster-peelers watch folks' manners;

Next cod and sturgeon with their gleaming scales,
Trumpet to mouth, are blowing—just like whales!

Lobsters (boiled red) dragoon as guards in chief—
The Kitchen's king, comes next, real English beef!

Frogs, flying footmen—coachmen, toad—and team
Of crayfish—and the Mayor's gilt coach now gleam;

The man in brass is a ridiculous mouse,
Followed by men at-arms from Mansion House;

And after them, contented and obese,
Waddle the City Companies, like geese.

DEAR! here are venison, and turkey big,
Saddle of mutton, and roast sucking pig,

Game, sausages, and pies to end the feast;
And then come beverages—last, not least!

Bear beer provides—of his own Brewin' spruce,
While Baboon Bacchus brings the grape's red juice.

The ingredients of the Dinner – hares, geese, lobsters,
turtles, turkeys, pigs – march to their doom, oblivious of
their fate.

Opposite, above, 'A Lord Mayor's Dinner? O dear, no. You
would not insinuate that anybody makes a beast of
himself there!'

Opposite, below, *A Ticket for Soup*. While aldermen guzzle,
the poor queue for free soup. (This illustration provides
an interesting comparison with such socially conscious
paintings of the early 1870s as Luke Fildes' *Waiting for
Admission at a Casual Ward*.

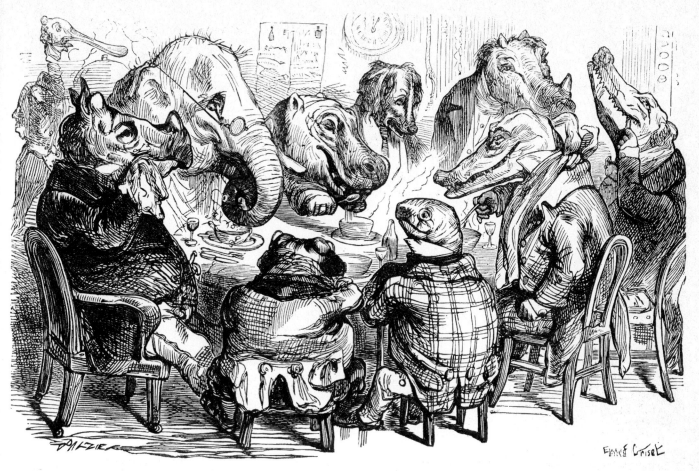

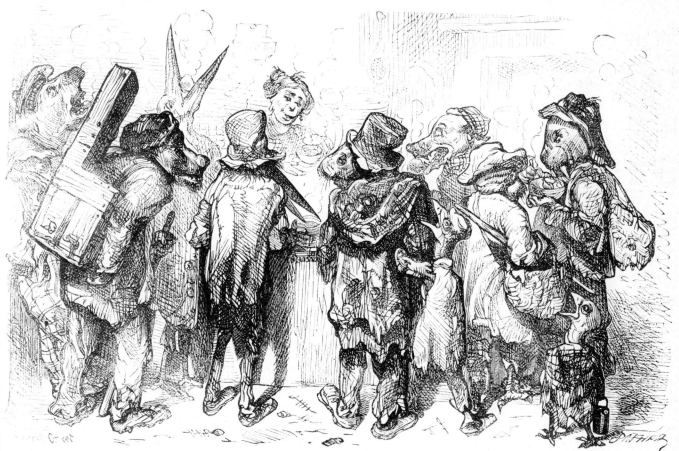

The Weighing Machine. '*Try yer weight, mum? Try yer weight?*'

Below, Griset shows cab-horses in heaven, a Utopian dream very different from their real lives as revealed in Anna Sewell's *Black Beauty* or in W. J. Gordon's *The Horse World of London*. One horse is smoking a meerschaum pipe in the shape of a man's head, a typical reversal of reality for such pipes were often carved with horses' heads.

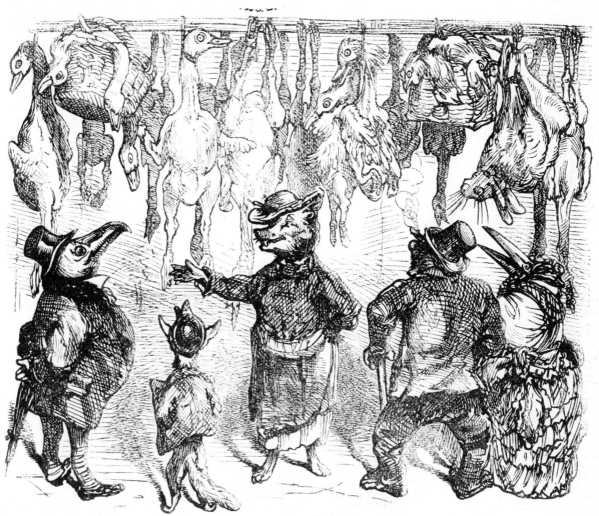

The fox, with his legendary cunning, fits naturally into
the role of fast-talking poultry salesman.

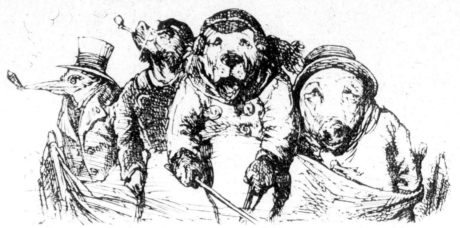

'Busses are "cusses" (Artemus,—ahem!)
Things that we all condemn:
Damp straw and windows draughty; conductors crafty,
Who, giving change, pass you bad sixpences with a callosity
Of conscience strange, and prone to range, if you expostulate, in ferocity,
Tempered by loud scurrility and incivility,
And slang employed with very much ability.
Boxes that jolt and jingle (with no good feature single);
Inside constructed just so wide as to insure
That every one with bunions, corns, or toes, terrific throes
Shall, as each passenger arrives, endure!

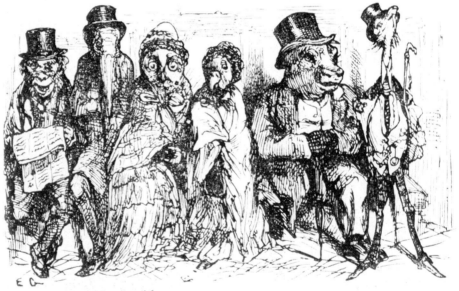

Or you may ride outside,
The knifeboard waits you; or, if you've a preference,
On the front seat; you may hold converse sweet
With driver—whom, of course, you treat with deference!—
And you will hear about the "chap he knowed
As drove that road some forty year—
Sunday or weekday, dry or wet:" a story to whose end you never get,
Because you always reach your destination
Before he's reached the point of his narration.
And then, at change of horse, comes this, of course—
"Stop, sir? Well, yes, we waits a minute here,
And—well, you're wery kind—a glass of beer."

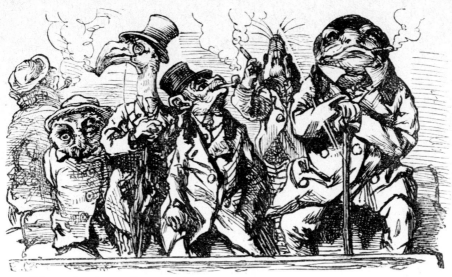

Then there are 'busses that act as "nusses,"
That strive their rivals to annoy and vex
And drive them off the road—no thought bestowed
On passengers, with chance of broken necks,
Or on the tender sex,
Who view, with horror painted on their faces,
The furious races ; seeing collision,
Wreck and disaster in prophetic vision !
Then come your fellow-passengers in 'busses—they too are cusses !
Shut up the window, and they growl and frown,
Yet scowl and grumble if you let it down !

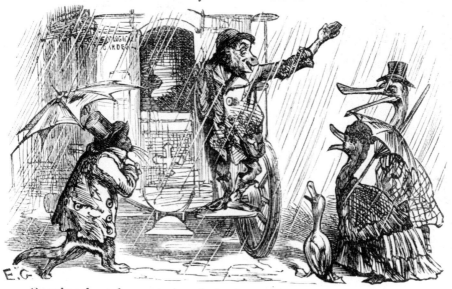

People who take up twice their share of room ;
People with bundles which the air perfume
With bloaters flavoury, and things unsavoury ;
Besides some people who are even worse,
Who cut your pockets and abstract your purse !
And lastly, there's the "last 'bus" for the night :
They're always full, and no one is polite
As—pitying your plight—" to ride outside, just to oblige a lady !"
But the discomforts all who can recall,
The bores and fusses of omnibuses?
 And so we'd better drop the subject shady.

Omnibuses. Degas once told Sickert that he much preferred travelling in omnibuses to cabs because in them one could study all human life. Griset shared this enthusiasm for the open-topped buses of his time and made drawings of them inside and out, with both human and animal passengers.

Select Bibliography

BOOKS ILLUSTRATED BY GRISET

The Hatchet Throwers by James Greenwood, London 1866
Griset's Grotesques or Jokes Drawn on Wood with rhymes by Tom Hood junior, London 1867
Legends of Savage Life by James Greenwood, London 1867
Among the Squirrels by Mrs Denison, London 1867
The Savage Club Papers, London 1867
The Purgatory of Peter the Cruel by James Greenwood, London 1868
The Bear King by James Greenwood, London 1868
Robinson Crusoe by Daniel Defoe, London 1869
Reynard the Fox: The Rare Romance of Reynard the Fox, London 1869
Aesop's Fables revised by J. B. Rundell, London 1869
Vikram the Vampire; or, tales of Hindoo Devilry adapted by Sir Richard Francis Burton, London 1870
Our Poor Relations: a philozoic essay by Sir Edward Bruce Hamley, Edinburgh and London 1872
Aunt Judy's Christmas Volume, London 1873
Ernest Griset's Funny Picture-Book, London 1874
The Favorite Album of Fun and Fancy, London 1880
Other Stories by Lord Brabourne, London 1880
The Mountain Sprite's Kingdom by Lord Brabourne, London 1881
Fifty-Three years among our Wild Indians by Colonel R. I. Dodge, New York 1882
Ferdinand's Adventures by Lord Brabourne, London 1883
The Plains of the Great West by Colonel R. I. Dodge, New York 1887
Hunting Scenes of the Great West by Colonel R. I. Dodge, New York 1887
A Child's Dream of the Zoo by William Manning, London 1889
Uncle Joe's Stories by Lord Brabourne, no date
National Nursery Rhymes, no date

PERIODICALS AND ANNUALS ILLUSTRATED BY GRISET

Fun, 1866–77
Punch, 1867–9
London Society, Volume XII, 1867
Good Words for the Young, 1870–1
Good Things, 1873
Little Folks, 1873–83
Hood's Comic Annual, 1879–83
Girl's Own Annual, 1880
Fun's Comical Creatures, London 1884
Girl's Own Annual, 1884
The Boy's Own Annual, 1894–1902
The Boy's Own Holiday Number, no date

FURTHER REFERENCES

While the biographical information on Griset is meagre in the extreme, it is possible, by referring to books on the history of the London Zoo, to pinpoint exactly the dates of many of his animal drawings and the subsequent fantasies derived from them. The last two books refer briefly to him.

The Zoological Society of London by Henry Scherren, London 1905
The Ark in the Park by Wilfrid Blunt, London 1976
The History of Punch by M. H. Spielman, London 1895
The Brothers Dalziel, a record of 50 years' work, London 1901